The Life of

Michelangelo

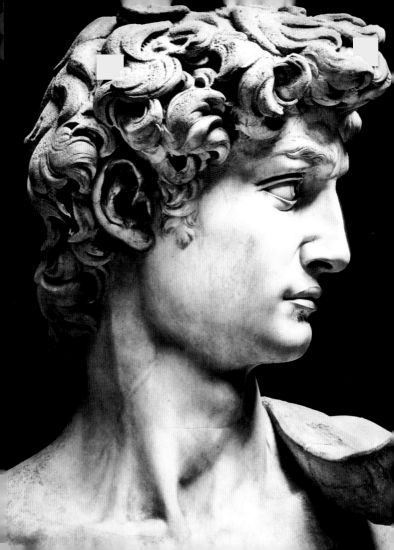

The Life of
Michelangelo

Giorgio Vasari

Introduction by David Hemsoll

The J. Paul Getty Museum, Los Angeles

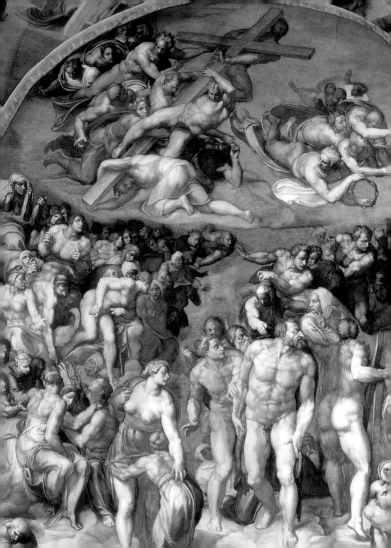

CONTENTS

Opposite: Detail from the Last Judgment, 1536-41

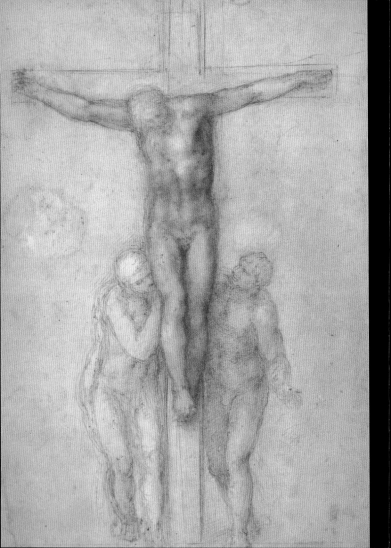

INTRODUCTION

DAVID HEMSOLL

The view that Michelangelo Buonarroti (1475-1564) was the greatest artist of his age was a widely shared one in the sixteenth century. He was, after all, personally responsible for several of the most ambitious and impressive creations of recent times in painting, sculpture and also architecture, such as the *David*, the Sistine Chapel ceiling, the *Last Judgment* and much of the rebuilding of New St Peter's. This view, however, received its fullest and most powerful literary expression in the biography of Michelangelo forming part of the *Lives of the Most Eminent Painters, Sculptures and Architects*, a work written by Giorgio Vasari (1511-74) and published in Florence originally in 1550 and again, in expanded form, in 1568. The *Lives* was itself a monumental enterprise, and one that has since come to be regarded as the prime initiating work of what is known as art history. Penned by a man who was also one of the most prolific and successful painters and architects of his day, it provides an extraordinary mass

Opposite: The Crucifixion with the Virgin and St. John, c. 1555-64

7

of detailed and mostly reliable information about all the main Italian artists of the previous three hundred years and all the major works that they produced; and, indeed, it has continued to be fundamental to our knowledge and understanding of Renaissance art, as attested to by the sheer number of subsequent editions and translations of the 1568 edition, including the one used for this publication. Vasari's *Life of Michelangelo* ('Michelagnolo' in the Florentine dialect) which was also issued as a separate booklet just a little later, exemplifies this achievement and supplies a vast multitude of facts about the artist's career and all its many triumphs and, in addition, equips the reader with many ready insights into how his works should be appreciated and provides many instant verdicts on their numerous special merits.

Although Vasari himself declared that the *Lives* were written for the principal benefit of artists, the book was plainly meant to be of value too to connoisseurs and anyone else with a stake or interest in the visual arts. It was, admittedly a work of some overt but understandable partiality towards his adoptive city of Florence but, at the same time, it was also one of some very considerable intellectual ambition. Above all, it was conceived in such a way as to elucidate an overall

concept of a gradual but sustained improvement in the visual arts, from a low point in the Middle Ages up to a level on a par with – or even surpassing – the achievements of classical antiquity. Vasari did this, in good part, by organising the book into three parts, each with an explanatory preface and corresponding to one of three successive periods. The first of these periods, which we now think of as being just prior to the Renaissance, 'prepared the way and formed the style for the better work which followed'; the second, corresponding to what is now widely termed the Early Renaissance, was one of 'manifest improvement'; and the third, now thought of as the High and Later Renaissance, was when art was finally to reach 'the summit of perfection'. A further stratagem was to present each of these three periods as having been initiated by individual ground-breaking figures, a schema which very notably reflected a Florentine bias and still lingers on in many surveys of Renaissance art today. Thus, for his first period, Vasari identified Giotto as the pioneer in painting although alongside two rather less deserving Florentines in sculpture and architecture; and, for his second, he drew justified attention to the Florentines Brunelleschi in architecture, Masaccio in painting and, in particular, Donatello in sculpture, whom he said he was minded to place in the third

period 'since his works are up to the level of the good antiques'. For this third period, however, Vasari was less fortunate with the realities of history, as is very clear from the preface to the third part, but he still made the best use of it he could, and did so too with one very clear final aim very much in his mind. He envisaged this period in such a way that it commences rather arbitrarily with the Florentine Leonardo da Vinci as its chief instigator in painting, thereby giving him precedence over such pioneering younger artists as Giorgione of Venice and Raphael of Urbino, but he then gave supremacy over them all to Florence's Michelangelo, whom he judged in both painting and sculpture, although conveniently ignoring architecture at least for the moment, to have eclipsed all others, and therefore to be the greatest artist not only of his age but of all time.

Michelangelo's portrayal in the *Lives* as the most accomplished of all artists, and as the very apogee of artistic progress, in fact underlies the book's whole structure, although this was much more readily apparent in the original 1550 edition. In this first edition, the three parts were of much more comparable size, with the biography of Michelangelo, which was already by far and away longest, being placed right at the end, and so providing a more balanced and

orderly work with a logical termination. The by now elderly but still very active Michelangelo, moreover, was accorded the unique privilege of being only artist included who was then still alive. In the revised 1568 edition of the *Lives*, however, much of this clarity was lost as a result of the book's third part being greatly expanded with new biographies of those artists who had either died since 1550 or who, like Titian, were still living, and with that of Michelangelo, who had since passed away, being now followed by a number of others. Michelangelo's biography, however, was now substantially longer even than in 1550, to become several times the length of those of his main artistic rivals Raphael and Titian. In consequence, it provided an even greater opportunity for detailing and explaining Michelangelo's unrivalled prowess and unequalled abilities.

Only in its final form, therefore, was the biography of Michelangelo to cover the whole of his life. Arranged very much like a classical biography, it consists of a detailed description of his career which is then followed by further material of a more general nature. The account of Michelangelo's career begins with his auspicious birth and early training and it chronicles his early works, including the *Bacchus* (1496-7) and the St Peter's *Pietà* (1497-9) in Rome,

before coming to the colossal and extraordinary stat-
ue of *David* (1501-4) in Florence and his unexecuted
scheme for the enormous painting of the *Battle of
Cascina* (1504-5). The narrative then turns to Rome
and the commission of the ill-fated Julius tomb
(1505) and its various sculptures, and to the execution
of the remarkable Sistine Chapel ceiling (1508-12); and
then back to Florence to chart the unexecuted project
for the façade of S. Lorenzo (1517-20), the architecture
and sculpture of the New Sacristy (from 1519) and the
design of the Laurentian Library (from 1523), togeth-
er with defensive works Michelangelo supervised
before and during the siege of Florence (1529-30).
Michelangelo's subsequent career in Rome begins
with a detailed discussion of the *Last Judgment* (1534-
41) and then continues with coverage, albeit some-
times rather cursory, of the frescoes in the Pauline
Chapel (from 1542), the Florence Cathedral *Pietà*
(from *c.* 1547) and various late architectural works in
Rome, including the Capitoline Palaces, the Porta Pia
and his unrealised project for S. Giovanni dei
Fiorentini, although it also devotes a very great deal of
space to the documentation of his constant labours on
New St Peter's (from 1546) and to various works of
consultation. This part of the biography then con-
cludes with an account of Michelangelo's death and

A battle scene, c. 1504

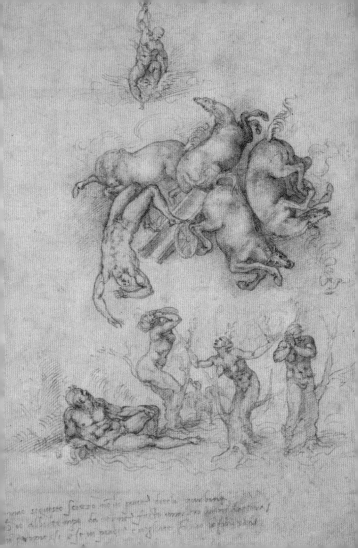

with a summary of the overall nature of his achieve-
ment. It is followed, however, with a great deal of fur-
ther information, not always very cogently structured,
about such matters as his character, his austerity in
private life, and his generosity in friendship, which
then leads to a digression on his practice of making
drawings as gifts, and also about his fondness for witty
observation and about his health and appearance. The
biography finally ends with an account of the surrep-
titious removal of Michelangelo's body from Rome to
Florence and a very lengthy description of his spec-
tacular civic funeral.

In redrafting the *Life*, Vasari made extensive
changes to its content. The original version had traced
Michelangelo's career up until the *Last Judgment*, and
so had terminated before the discussion of St Peter's
and the rest of the late work, and it had done so in a
fairly well organised and evenly paced manner. The
1568 version supplied the remaining biographical
material, as well as the description of the funeral,
which closely follows an account of it first published
for the occasion as a pamphlet, and so it became much
fuller but rather less well structured than before. It was

*Opposite: preparatory sketch for The Fall of the Chariot of the Sun (or The
Fall of Phæton), a gift for Tommaso de' Cavalieri; sent to Tommaso for
approval, 1533*

also markedly different in tone in that, for the first version, Vasari had just used material derived from reliable sources to hand and so with little if any of it coming from Michelangelo directly, whereas, for the revised version, he now made full use of his own more recent acquaintance with Michelangelo, and did so by making frequent reference to his personal dealings with the artist, as well as reproducing several actual letters that had passed between them. In this way, the revised *Life* gained a new authenticity and credibility by giving an impression that it had been approved by Michelangelo himself. The 1568 version, however, was not just an extended version of its predecessor. It was also substantially rewritten to take account of another biography of Michelangelo that had appeared in 1553, a work produced by Michelangelo's own pupil Ascanio Condivi and containing a great deal of material, much of it gleaned from Michelangelo himself, that Vasari had not originally included. Much of this new information Vasari duly incorporated, including Condivi's contention that the artist's ancestral lineage could be traced back to the illustrious and noble Canossa family, as well as a great many new details relating to the protracted history of the Julius tomb. Yet Vasari certainly did not consider everything in Condivi's biography to be reliable, as he made abundantly clear when describing

Michelangelo's artistic training in the workshop of
Domenico Ghirlandaio. His original account of this
had been explicitly contradicted by Condivi who had
insisted instead that Michelangelo had never had any
teacher, but Vasari was now to prove his position by
publishing the actual official record of Michelangelo's
apprenticeship. This rebuttal of Condivi, however, was
not simply a matter of scholarly vindication, since
Vasari could not afford, in either 1550 or 1568, to be
shown to be factually inaccurate and was, as he put it,
making his point in the 'interests of truth,' in just the
same way that he was recording all the rest material in
the biography. For this 'truth' not only applied to the
detail of Michelangelo's life but also supplied the very
foundation, as Vasari surely must himself have gen-
uinely believed, to the whole estimation of his art.

The *Life*, in fact, is not a true biography in the
strictest sense but, rather, an account of Michelangelo
as an artistic personality to the exclusion of almost
everything else. As such, it deals only with his artistic
career and matters directly impinging on it, such as his
close personal relationships with popes and other illus-
trious patrons. It certainly includes many amusing
anecdotes, among which are several incidents of
Michelangelo bettering those who did not sufficiently
understand or value his art, such as his patron Agnolo

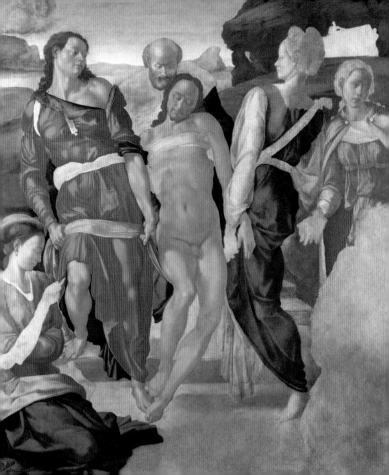

Doni who attempted to acquire the painting of the *Holy Family* that Michelangelo produced for him at a knock down price only to end up having to pay double the originally agreed amount; or the agent of the duke of Ferrara who made disdainful comments about the painting of *Leda* Michelangelo commissioned by his master only to see him refuse to hand it over and give it instead to one of his pupils. It also freely acknowledged some of Michelangelo's more notorious or eccentric working practices, such as his obsession for working in solitude and secrecy or, more personally, his habit of sometimes not getting round to changing his clothes. On the other hand, the *Life* pays little or no regard to other aspects of Michelangelo's world. Thus it provides virtually no insight into his relationships with other members of his family, and no explanation of the animosity borne him by such figures as duke Alessandro de' Medici, and, famously, it makes no direct mention of his romantic inclinations, or even of whether he ever had any. Nor does it make any reference to events in the wider world, however momentous, unless they had made an immediate impact on Michelangelo's professional activity, or any

Opposite: The Entombment (unfinished), c. 1501-02

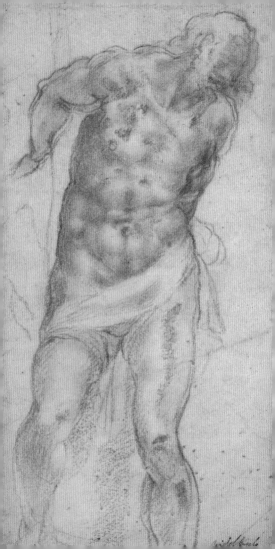

acknowledgement that changes in society had made any effect on his work. The *Life*, in fact, is not only centred on Michelangelo's artistic career but it does so in such a way as to show it to best advantage. Consequently, it makes little comment on Michelangelo's recognised abilities as a poet, so as not to detract from his much higher accomplishments in art. It also cleverly marginalises some of Michelangelo's less successful ventures, such as making only the barest mention, inserted towards the end of the *Life*, of his time spent in collaboration with the Venetian painter Sebastiano del Piombo, after completing the Sistine Chapel ceiling, when the two were engaged on producing works in direct competition with Raphael.

Vasari conveyed Michelangelo's artistic excellence, to a great extent, by simply asserting the various special qualities and noteworthy features of his individual works. This technique can be seen to particular effect, for example, in the description of the St Peter's *Pietà*, where the prose, although flowery, is especially powerful, and the work is described as demonstrating 'the utmost limits of sculpture,' with the figure of the dead Christ representing the 'miracle that a once shapeless

Opposite: Christ at the Column, 1516, prepared for Sebastiano del Piombo's Flagellation of Christ, S. Pietro in Montorio, Rome

stone should assume a form that Nature with difficulty produces in flesh.' A similar strategy was followed for many other works, and particular so for the preliminary cartoon for the *Battle of Cascina*, the Sistine Chapel ceiling, and the statue of *Night* in the New Sacristy, which if completed Vasari says would have shown how art could surpass Nature 'in every thought.' The same strategy is also followed for the *Last Judgment*, which is very much a tour de force of this approach, and here Vasari's intention was not just to pronounce on the painting's many merits but to do so in such a way that would flatly contradict many of the contemporary criticisms, some quite justifiable, that were being levelled at it by detractors such as Pietro Aretino, who had scathingly attacked it in a letter addressed personally to Michelangelo of 1545. Thus, in tacit response to Aretino condemning the nudity as unsuitable to the pope's official chapel, Vasari instead draws frequent attention to 'ideas appropriate to such a work;' and in defiance of the widely held view of Michelangelo's shortcomings in his representation of women, and in painting's more demanding refinements, Vasari instead insists on his

Opposite: Angels with instruments of the Passion, St Peter with other saints below, from the Last Judgment, 1534–41

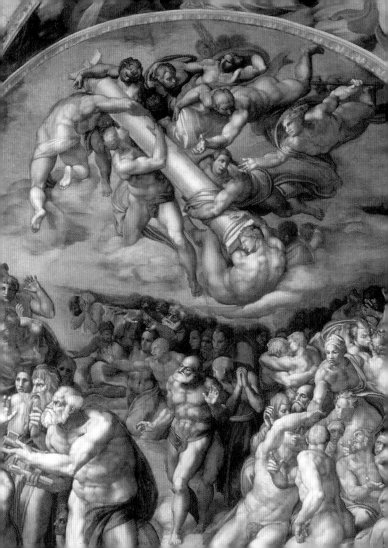

superiority in depicting women of all ages as well as men, and on his ability to achieve a 'mellow softness and harmony' and an exacting attention to detail. Certain remarks by Vasari about other works by Michelangelo may have been prompted too by adverse comment, such as his description of the prophet Jonah on the Sistine Chapel ceiling as defying the curvature if the vault so as to appear 'really to be bending backwards,' considering that Michelangelo had so conspicuously failed to follow the convention of representing overhead figures in accordance with a foreshortened and *dal di sotto in su* ('from below upwards') overall perspective.

Vasari nevertheless had some very considerable difficulties in arguing for Michelangelo's artistic preeminence in painting, just as he would also do in architecture. The problem with painting was, simply, that Michelangelo's works were so very plainly inferior, at least in certain particular respects, to what might be expected from the works of other great modern practitioners such as Raphael or Titian. Vasari was prepared to admit, in connection with the *Last Judgment*, that Michelangelo had 'neglected the charming colouring, fancies, new ideas with details and elegances which many other painters do not entirely neglect,' but he sought to present any such

perceivable deficiencies as being but trivial in comparison with Michelangelo's unrivalled mastery of the human figure and its drawing. That Vasari believed drawing, or rather 'design' (in Italian *disegno*), to be the most fundamental, and therefore most laudable, aspect of painting also underlies his discussion of other works, such as the *Battle of Cascina* cartoon which, although just a drawing, is hailed by Vasari as an exemplary model of what painting could achieve. For architecture, Vasari's difficulties were even greater, since it was even harder to point to a theoretical framework that would demonstrate Michelangelo's unequalled achievement, and since it was most unwise simply to contradict the prevailing opinion that it was Bramante who was modern architecture's greatest exponent as well as its leading pioneer, as Vasari had pointedly failed to mention in the preface to the third part of the *Lives*. Vasari's solution, in part, was to grant some considerable but still limited praise to Bramante in his *Life* of this architect, by saying that he had paved the road for those subsequently to follow, but then to distance Michelangelo from this achievement and imply a new one of his own by stating, in connection with the New Sacristy and the Laurentian Library, that he had succeeded in breaking 'the chains' that had forced other architects to all work in the same

DAVID HEMSOLL

way, and so had provided them with a new freedom. Another of Vasari's techniques with architecture was to rely on description and the parading of architectural terminology as a substitute for explanation, as is most notably the case with his treatment of Michelangelo's work on St Peter's, where he also gave only the briefest of reminders that it was actually Bramante who had established the main outlines of the building. In fact, when coming to Michelangelo's scheme for the immense drum and dome, his narrative bombards us with a well nigh interminable detailing of absolutely all its components and enumeration of all its dimensions.

In several important respects Vasari's account reflects Michelangelo's own views of his art. Above all, this can be seen in the prominence accorded to the notion of imaginative invention, or again 'design', which is now given much more emphasis than, say, in the preface to the third part of the *Lives*. Vasari, like Michelangelo, thus connected the concept with a belief that the chief aim in art was to depict the human body, as he was to make very clear from his discussion of the *Last Judgment*, and from also linking the

Opposite: Section through the dome of St Peter's and figure studies, late 1550's. For verso, see p. 28

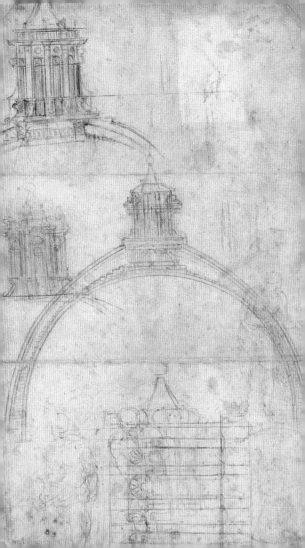

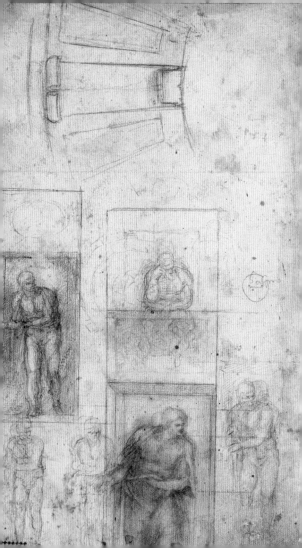

concept with Michelangelo's renewed enthusiasm for the study of anatomy, so as to understand its underlying principles that much better. Vasari was less explicit, although he doubtless saw the connection, that the concept was also related to the practice he mentioned Michelangelo following in sculpture, of gradually revealing the figure from the block rather as if it were slowly emerging from the surface of a vessel of water. Vasari would likewise have understood its relationship also to Michelangelo's recorded principle of basing the proportions of figures on his own judgment rather than on any given set of rules, and in him then adopting a similar approach to architecture. Indeed, it would be through Michelangelo's unprecedented and unparalleled command of this very concept of 'design', which in his general introduction to the *Lives* is actually described as the 'parent' of all three arts of painting, sculpture and architecture, that Michelangelo could be reasoned by Vasari to have surpassed even the ancients, and be, as Vasari declared him to be, the greatest exponent of all the arts of all time.

Vasari's understanding of Michelangelo's art and achievement, however, also relied on a further concept,

Opposite: Ground plan of the base of the lantern of St Peter's and figure studies, late 1550's. Verso of sheet illustrated on p. 27

DAVID HEMSOLL

which was directly related to that of 'design,' and was to have the greatest ramifications for conceptions of a 'great artist' ever since. Put simply, Vasari believed that art, and in particular Michelangelo's art, was based on ideas that were pre-formed in the artist's mind and relied on the innate ability granted him by the grace of God. His conviction over Michelangelo's especially privileged position in this regard surfaces throughout the *Life*, and is implicit in his frequent use of the term 'divine' in connection with his art, a term he also used in relation to other exalted artists although never as often as with Michelangelo. Nor was Vasari's use of the word in specific connection with Michelangelo actually innovative, since it had been previously applied to him by Aretino in his 1545 letter, although there as a mocking jibe. Yet Vasari seems to have employed it in an especially sincere and purposeful manner, and in a way that is consistent with his use of other heavenly allusions or references, such as his remarkable claim that the *Last Judgment* was actually inspired by God directly. In fact, he gave this view its most explicit and extensive airing in the opening paragraphs of the *Life*, where he describes, with extraordinary

Opposite: A male head in profile, related to an ignudo on the Sistine Ceiling; studies of limbs, c. 1511. For verso, see p. 32

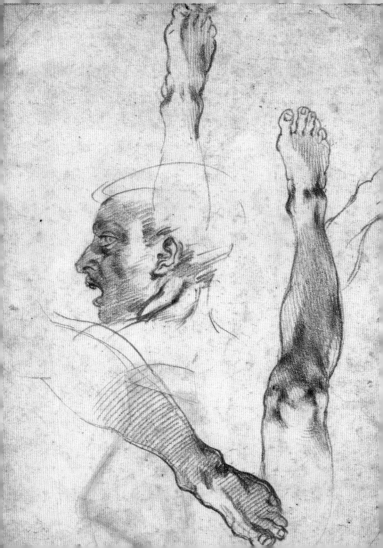

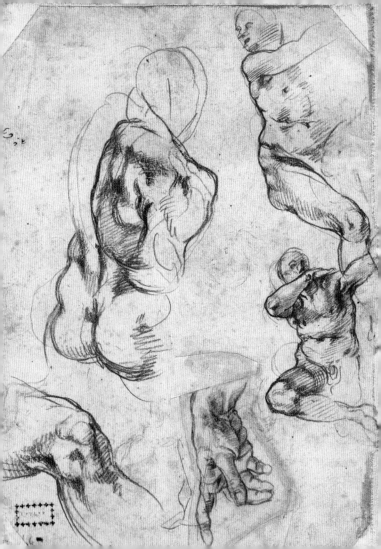

theological resonance, how the 'ruler of heaven' himself had resolved to save the world from further error and send it a figure who would excel in painting, sculpture and architecture, and, in addition, would be endowed with such exceptional gifts that he would be followed in life, work and all other endeavours, and be acclaimed by us as being more celestial than earthly. Much of what then follows, therefore, can be regarded as an affirmation of this initial premise, which is certainly one which very much inflects his assessment, say, of the Sistine Ceiling as a 'veritable beacon' of art that had brought light to a world which had 'remained in darkness' for centuries; or of the *David,* where Vasari describes Michelangelo's transformation of an abandoned and mutilated block of marble as a true 'miracle' in resuscitating what had previously been 'dead.' A similar belief in Michelangelo as a divinely favoured and, indeed, saintly figure may also help explain the lengths his fellow Florentines went to in order to have his remains returned to his native city after his death, which involved them stealing the body and bringing it to the city disguised as merchandise, rather in the way that, for example, the Venetians much

Opposite: Studies for God the Father and attendant angels, c. 1511.
Verso of sheet illustrated on p. 31

earlier had acquired the body of St Mark for their city. For these devout followers, their faith in him would have been all the more confirmed when his coffin was briefly opened, and his body was found, like many a saint's, as not showing signs of decomposition but instead, as Vasari recounts, as being untouched in every part and without any bad odour, so that he seemed just 'to be quietly sleeping'. For them too, such a faith would sustain their conviction that he had truly been 'the greatest man their art had ever known,' just as a belief in his genius would inspire the ways his achievements would be looked upon by all his very many devotees and enthusiasts thereafter.

MICHELAGNO BVONAR. PIT.
SCVLTORE ET ARCHITET

The Life of Michelangelo Buonarroti
Painter, Sculptor and Architect
of Florence

GIORGIO VASARI

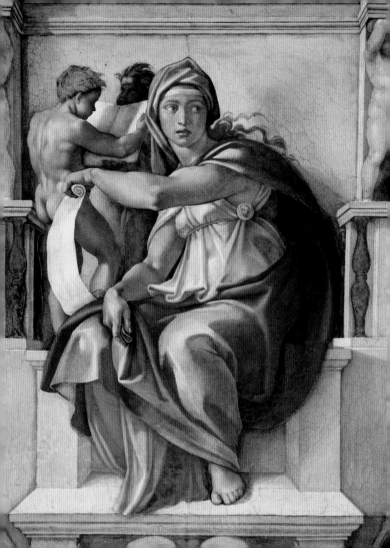

W HILE industrious and choice spirits, aided by the light afforded by Giotto and his followers, strove to show the world the talent with which their happy stars and well-balanced humours had endowed them, and endeavoured to attain to the height of knowledge by imitating the greatness of nature in all things, the great Ruler of Heaven looked down and seeing these vain and fruitless efforts and the presumptuous opinion of man, more removed from truth than light from darkness, resolved, in order to rid him of these errors, to send to earth a genius universal in each art, to show single-handed the perfection of line and shadow, and who should give relief to his paintings, show a sound judgment in sculpture, and in architecture should render habitations convenient, safe, healthy, pleasant, in proportion, and enriched with various ornaments. He further endowed him with true moral philosophy and a sweet poetic spirit, so that the world should marvel at the singular eminence of his life and works and all his actions, seeming rather divine than earthly.

In the arts of painting, sculpture, and architecture the Tuscans have always been among the best,

Opposite: The Delphic Sibyl, from the Sistine Ceiling, 1509-12

and Florence was the city in Italy most worthy to be the birthplace of such a citizen to crown her perfections. Thus in 1474 the true and noble wife of Ludovico di Lionardo Buonarroti, said to be of the ancient and noble family of the counts of Canossa, gave birth to a son at Casentino, under a lucky star. The son was born on Sunday, March 6, at eight in the evening, and was called Michelagnolo, as being of a divine nature, for Mercury and Venus were in the house of Jove at his nativity, showing that his works of art would be stupendous. Ludovico at the time was podestà at Chiusi and Caprese near the Sasso della Vernia, where St Francis received the stigmata, in the diocese of Arezzo. On laying down his office Ludovico returned to Florence, to the villa of Settignano, three miles from the city, where he had a property inherited from his ancestors, a place full of rocks and quarries of sandstone which are constantly worked by stone-cutters and sculptors who are mostly natives. There Michelagnolo was put to nurse with a stone-cutter's wife. Thus he once said jestingly to Vasari: 'What good I have comes from the pure air of your native Arezzo, and also because I sucked in chisels and hammers with my nurse's milk.' In time Ludovico had several children, and not being well off, he put them in the arts of wool and silk.

When Michelagnolo had grown a little older, he was placed with Maestro Francesco da Urbino to school. But he devoted all the time he could to drawing secretly, for which his father and seniors scolded and sometimes beat him, thinking that such things were base and unworthy of their noble house.

About this time Michelagnolo made friends with Francesco Granacci, who though quite young had placed himself with Domenico del Ghirlandaio to learn painting. Granacci perceived Michelagnolo's aptitude for design, and supplied him daily with drawings of Ghirlandaio, then reputed to be one of the best masters not only in Florence but throughout Italy. Michelagnolo's desire thus increased daily, and Ludovico perceiving that he could not prevent the boy from studying design, resolved to derive some profit from it, and by the advice of friends put him with Domenico Ghirlandaio that he might learn the profession. At that time Michelagnolo was fourteen years old. As the author* of his life, written after 1550 when I first published this work, has stated that some through not knowing him have omitted things worthy of note and stated others that are not true, and in particular

*Ascanio Condivi

he taxes Domenico with envy, saying that he never assisted Michelagnolo, this is clearly false, as may be seen by a writing in the hand of Ludovico written in the books of Domenico now in the possession of his heirs. It runs thus:—

> 1488. Know this 1 April that I, Ludovico di Lionardo Buonarroto, apprentice my son Michelagnolo to Domenico and David di Tommaso di Currado for the next three years, with the following agreements; that the said Michelagnolo shall remain with them that time to learn to paint and practise that art and shall do what they bid him, and they shall give him 24 florins in the three years, 6 in the first, 8 in the second and 10 in the third, in all 96 lire.

Below this Ludovico has written:

> Michelagnolo has received 2 gold florins this 16 April, and I, Ludovico di Lionardo, his father, have received 12 lire 12 soldi.

I have copied them from the book to show that I have written the truth, and I do not think that any

Opposite: An old man wearing a hat (The Philosopher), c. 1495-1500, showing the influence of Ghirlandaio. For verso of this sheet see p. 42

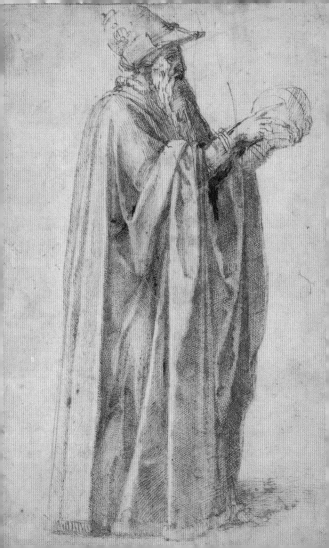

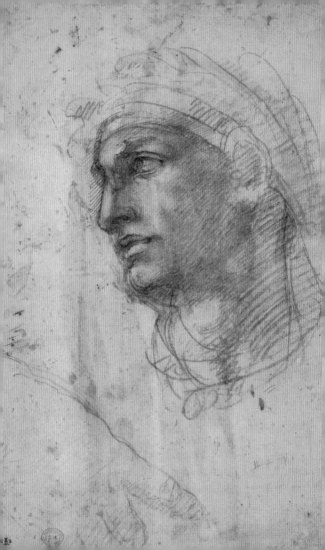

one has been a greater and more faithful friend to him than I, or can show a larger number of autograph letters. I have made this digression in the interests of truth, and let this suffice for the rest of the *Life*. We will now return to the story.

Michelagnolo's progress amazed Domenico when he saw him doing things beyond a boy, for he seemed likely not only to surpass the other pupils, of whom there were a great number, but would also frequently equal the master's own works. One of the youths happened one day to have made a pen sketch of draped women by his master. Michelagnolo took the sheet, and with a thicker pen made a new outline for one of the women, representing her as she should be and making her perfect. The difference between the two styles is as marvellous as the audacity of the youth whose good judgment led him to correct his master. The sheet is now in my possession, treasured as a relic. I had it from Granacci with others of Michelagnolo, to place in the Book of Designs.* In 1550, when Giorgio showed it to Michelagnolo at Rome, he recognized it with

* Vasari's collection of drawings. This sheet is lost.

Opposite: Head of a Youth and a right hand, c. 1508-10. These studies similar to those made for the ignudi on the Sistine ceiling, are on the verso of the earlier drawing of the Philosopher (p. 41)

delight, and modestly said that he knew more of that art when a child than later on in life.

One day while Domenico was engaged upon the large chapel of S. Maria Novella, Michelagnolo drew the scaffolding and all the materials with some of the apprentices at work. When Domenico returned and saw it, he said, 'He knows more than I do,' and remained amazed at the new style produced by the judgment of so young a boy, which was equal to that fine artist of many years' experience. To this Michelagnolo added study and diligence so that he made progress daily, as we see by a copy of a print engraved by Martin the German,* which brought him great renown. When a copper engraving by Martin of St Anthony beaten by the devils reached Florence, Michelagnolo made a pen drawing and then painted it. To counterfeit some strange forms of devils he bought fish with curiously coloured scales, and showed such ability that he won much credit and reputation. He also made perfect copies of various old masters, making them look old with smoke and other things so that they could not be

* Martin Schongauer. A painting recently acquired by the Kimbell Art Museum, Fort Worth, has been identified by some experts as Michelangelo's copy

distinguished from the originals. He did this to acquire the style of those whom he admired, and he sought to surpass them, thereby acquiring a great name.

At this time Lorenzo de' Medici the Magnificent kept Bertoldo the sculptor in his garden on the piazza of S. Marco, not so much as the custodian of the numerous collections of beautiful antiquities there, as because he wished to create a school of great painters and sculptors with Bertoldo as the head, who had been pupil of Donato [Donatello]. Although old and unable to work, he was a master of skill and repute, having diligently finished Donato's pulpits and cast many bronze reliefs of battles and other small things, so that no one then in Florence could surpass him. Lorenzo, who loved painting and sculpture, was grieved that no famous sculptors lived in his day to equal the great painters who then flourished, and so he resolved to found a school. Accordingly he asked Domenico Ghirlandaio that if he had any youths in his shop inclined to this he should send them to the garden, where he would have them instructed so as to do honour to him and to the city. Domenico elected among others Michelagnolo and Francesco Granacci as being the best. At the garden they found that Torrigiano was modelling clay figures given to him by Bertoldo.

Michelagnolo immediately did some in competition, and Lorenzo seeing his genius, always expected great things of him. Thus encouraged, the boy began in a few days to copy in marble an antique faun's head, smiling, with a broken nose. With a few strokes he imitated it so well that Lorenzo was amazed. Seeing that in addition the boy had opened its mouth and made the tongue and all the teeth, Lorenzo jestingly said, for he was a pleasant man, 'You ought to know that the old never have all their teeth, and always lack some.' Michelagnolo, who loved and respected his patron, took him seriously in his simplicity, and so soon as he was gone he broke out a tooth and made the gum look as if it had fallen out. He anxiously awaited the return of Lorenzo, who, when he saw Michelagnolo's simplicity and excellence, laughed more than once, and related the matter to his friends as a marvel.* He returned to help and favour the youth, and sending for his father, Ludovico, asked him to allow him to treat the boy as his own son, a request that was readily granted. Accordingly Lorenzo gave Michelagnolo a room in the palace, and he ate regularly at table with the

* The *Faun* is lost, but a fresco by Octavio Vannini in the Palazzo Pitti may record its appearance

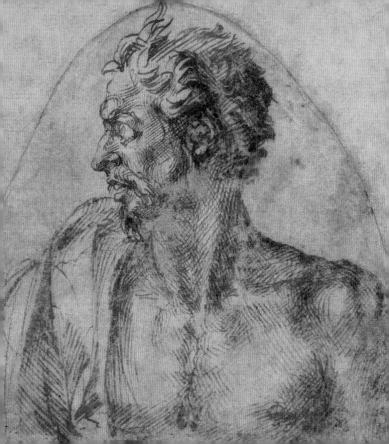

family and other nobles staying there. This was the year after he had gone to Domenico, when he was fifteen or sixteen, and he remained in the house for four years until after the death of Lorenzo in '92. I hear that he received a provision of five ducats a months at this time from Lorenzo, who also gave him a violet mantle, and conferred an office in the customs upon his father. Indeed all the youths in the garden received a greater or less salary from that noble citizen, as well as rewards.

By the advice of Poliziano, the famous man of letters, Michelagnolo did a fight between Hercules and the Centaurs* on a piece of marble given him by that signor, of such beauty that it seems the work of a consummate master and not of a youth. It is now preserved in his house by his nephew Lionardo as a precious treasure, in memory of him. Not many years since this Lionardo had a Madonna bas-relief by his uncle, more than a braccia high,† in imitation of Donatello's style, so fine that it seems the work of that master, except that it possesses more grace and design. Lionardo gave it to Duke Cosimo, who values it highly as he possesses no other bas-relief of the master.

* Casa Buonarroti, Florence † Casa Buonarroti, Florence. A Florentine braccia was 58.3 cm or $22^{19}/_{20}$ Imperial inches.

To return to Lorenzo's garden. It was full of antiquities and excellent paintings, collected there for beauty, study, and pleasure. Michelagnolo had the keys, and was much more highly favoured than the others in all his actions. For many months he drew Masaccio's paintings in the Carmine, showing such judgment that he amazed artists and others, and also roused envy. It is said that Torrigiano made friends with him, but moved by envy at seeing him more honoured and skilful than himself, struck him so hard on the nose that he broke it and disfigured him for life. For this Torrigiano was banished from Florence, as is related elsewhere.

On the death of Lorenzo, Michelagnolo returned home, much grieved at the loss of that great man and true friend of genius. Buying a large block of marble, he made a Hercules of four braccia, which stood for many years in the Strozzi palace, and was considered remarkable*. In the year of the siege it was sent to King Francis of France by Giovambattista della Palla. It is said that Piero de' Medici, who had long associated with Michelagnolo, often sent for him, wishing to buy antique cameos and other intaglios, and one snowy winter he got him

* Lost

to make a beautiful snow statue in the court of his palace. He so honoured Michelagnolo for his ability, that his father, seeing him in such favour with the great, clothed him much more sumptuously than before. For S. Spirito in Florence Michelagnolo made a wooden crucifix, put over the lunette above the high altar to please the prior, who gave him suitable rooms.* By frequently dissecting dead bodies to study anatomy, he began to perfect his great design. At the time of the expulsion of the Medici from Florence, Michelagnolo had gone to Bologna a few weeks before the event, and had then proceeded to Venice, fearing evil consequences from Piero's arrogance and bad government, for he was a member of the household. Finding no means of existence at Venice, he returned to Bologna, where he had the misfortune not to take the countersign on entering the gate to permit him to go out again, for M. Giovanni Bentivogli had ordained that those who had not the countersign should be condemned to pay fifty lire. Michelagnolo was in great distress, being unable to pay, but M. Giovanfrancesco Aldovrandi, one of the sixteen governors, took compassion on

* Possibly the crucifix discovered in storeroom of Santo Spirito, now exhibited at the Casa Buonarroti, Florence

him, made him relate the circumstances, released him, and entertained him in his house for more than a year. One day Aldovrandi took him to see the ark of St Dominic, made by Giovanni Pisano and Maestro Niccolo da l'Arca, the old sculptors. He asked him if he had the courage to do an angel holding a candlestick, and a St Petronius, figures of about a braccia, that were wanting. Michelagnolo replied in the affirmative, and on receiving the marble, made them, and they are the best figures there.* He received thirty ducats for both from M. Francesco Aldovrandi. He remained rather more than a year at Bologna, and would have stayed longer to please Aldovrandi, who loved him for his design, and liked to hear him read Dante, Petrarch, Boccaccio, and other Tuscan poets with his Tuscan accent. But perceiving that he was wasting time, Michelagnolo willingly returned to Florence. There he did a marble St John† for Lorenzo di Pierfrancesco de' Medici, and then began a life-size sleeping Cupid also in marble.§ When done Baldassari del Milanese caused it to be shown to Pierfrancesco, who said, 'If you buried it, I feel sure that it would pass for an antique at Rome if made to

* Still in situ † Lost § Lost

appear old, and you would get much more than by selling it here.' It is said that Michelagnolo made it appear antique, and indeed it was an easy matter. Others declare that Milanese took it to Rome, buried it at his villa, and then sold it as an antique for two hundred ducats to the Cardinal San Giorgio. It is also said that Milanese wrote to Pierfrancesco telling him to give thirty scudi to Michelagnolo, as he had not obtained more for the Cupid, thus deceiving the cardinal, Pierfrancesco, and Michelagnolo. But it afterwards became known that the Cupid had been made in Florence, and Milanese's agent was forced to restore the money and take back the figure. It came subsequently into the hands of Duke Valentino, who gave it to the Marchioness of Mantua, and she took it home to that city where it now is. The Cardinal San Giorgio did not escape blame for not recognizing the merit of the work, for when the moderns equal the ancients in perfection it is a mere empty preference of a name to the reality when men prefer the works of the latter to those of the former, though such men are found in every age. The noise of this matter so increased Michelagnolo's reputation that he was immediately invited

Opposite: Bacchus, 1496-98

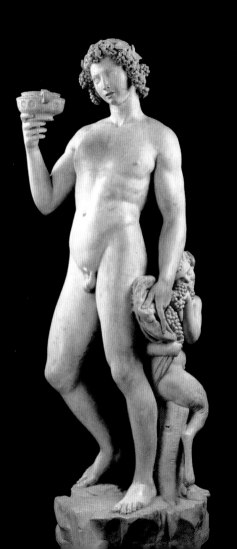

to Rome and engaged by the Cardinal San Giorgio. He stayed nearly a year, but the cardinal, knowing little of art, did little for him.

At that time the cardinal's barber, who coloured in tempera very diligently but could not design, made friends with Michelagnolo, who made him a cartoon of St Francis receiving the stigmata, which the barber executed in colours on a small panel, with great diligence. It is now in the first chapel on the left on entering S. Pietro in Montorio*. M. Jacopo Galli, an intelligent Roman noble, recognized Michelagnolo's ability, and employed him to make a marble Cupid of life size,† and then to do a Bacchus of ten palms holding a cup in the right hand, and in the left a tiger's skin and a bunch of grapes with a satyr trying to eat them.§ These figures show a marvellous blending in the limbs of the slenderness of a youth and the fleshy roundness of a woman, proving Michelagnolo's superiority to all the moderns in statuary. During his stay in Rome he made such progress in art that his conceptions were marvellous, and he executed difficulties with the utmost ease, frightening those who were not accustomed to see such things, for when they were done

* Lost † Lost § Museo Nazionale del Bargello, Florence

the works of others appeared as nothing beside them. Thus the cardinal of St Denis, called Cardinal Rohan, a Frenchman, desired to leave a memorial of himself in the famous city by such a rare artist, and got him to do a marble Pietà, which was placed in the chapel of S. Maria della Febbre on the temple of Mars, in St Peter's.* The rarest artist could add nothing to its design and grace, or finish the marble with such polish and art, for it displays the utmost limits of sculpture. Among its beauties are the divine draperies, the foreshortening of the dead Christ, and the beauty of the limbs with the muscles, veins, sinews, while no better presentation of a corpse was ever made. The sweet air of the head and the harmonious joining of the arms and legs to the torso, with the pulses and veins, are marvellous, and it is a miracle that a once shapeless stone should assume a form that nature with difficulty produces in flesh. Michelagnolo devoted so much love and pains on this work that he put his name on the girdle crossing the Virgin's breast, a thing he never did again. One morning he had gone to the place to where it stands and observed a number of Lombards who were praising it loudly. One of them asked another the

* Still in St. Peter's, but not in its original position

name of the sculptor, and he replied, 'Our Gobbo of Milan.' Michelagnolo said nothing, but he resented the injustice of having his work attributed to another, and that night he shut himself in the chapel with a light and his chisels and carved his name on it. It has been thus aptly described—

> *Bellezza ed onestate*
> *E doglia e pieta in vivo marmo morte,*
> *Deh, come voi pur fate*
> *Non piangete si forte*
> *Che anzi tempo risveglisi da morte.*
> *E pur, mal grado suo*
> *Nostra Signore e luo*
> *Sposo, figliuolo e padre*
> *Unica sposa sua figliuola e madre.* *

It brought him great renown, and though some fools say that he has made the Virgin too young, they ought to know that spotless virgins keep their youth

* 'Beauty and worth, grief and pity dead in the living marble, weep not thus, be comforted, time will awake the dead. He who is Our Lord and thine, spouse, son and father, thou His only spouse, daughter and mother.' The lines, by G. B. Strozzi, were in fact written about a Pietà by Nanni di Baccio Bigio

Opposite: The Pietà, 1501

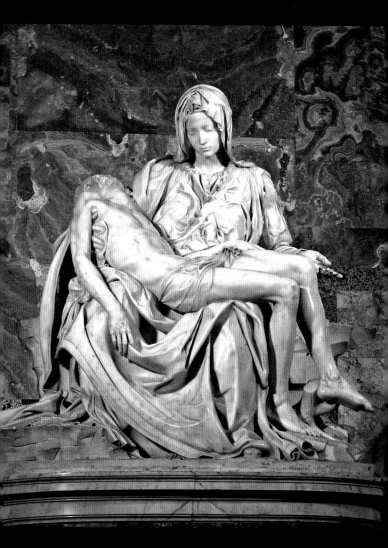

for a long time, while people afflicted like Christ do the reverse, so that this contributed more to increase the fame of his genius than all the things done before.

Some of Michelagnolo's friends wrote from Florence urging him to return, as they did not want that block of marble on the Opera to be spoiled which Piero Soderini, then gonfaloniere for life in the city, had frequently proposed to give to Leonardo da Vinci, and then to Andrea Contucci, an excellent sculptor, who wanted it. Michelagnolo on returning tried to obtain it, although it was difficult to get an entire figure without pieces, and no other man except himself would have had the courage to make the attempt, but he had wanted it for many years, and on reaching Florence he made efforts to get it. It was nine braccia high, and unluckily one Simone da Fiesole had begun a giant very badly executed, cutting between the legs, so that the wardens of S. Maria del Fiore had abandoned it without wishing to have it finished, and it had rested so for many years. Michelagnolo examined it afresh, and decided that it could be hewn into something new while following the attitude sketched by Simone, and he decided to ask the wardens and Soderini for it. They gave it to him as a useless thing, thinking that anything he might do would be better

than its present useless condition. Accordingly Michelagnolo made a wax model of a youthful David holding the sling to show that the city should be boldly defended and righteously governed, following David's example. He began it in the Opera, making a screen between the walls and the tables, and finished it without any one having seen him at work. The marble had been hacked and spoiled by Simone so that he could not do all that he wished with it, though he left some of Simone's work at the end of the marble, which may still be seen. This revival of a dead thing was a veritable miracle. When it was finished various disputes arose as to who should take it to the piazza of the Signori, so Giuliano da Sangallo and his brother Antonio made a strong wooden frame and hoisted the figure on to it with ropes; they then moved it forward by beams and windlasses and placed it in position. The knot of the rope which held the statue was made to slip so that it tightened as the weight increased, an ingenious device, the design for which is in our book, showing a very strong and safe method of suspending heavy things. Piero Soderini came to see it, and expressed great pleasure to Michelagnolo who was retouching it, though he said he thought the nose large. Michelagnolo seeing the gonfaloniere below

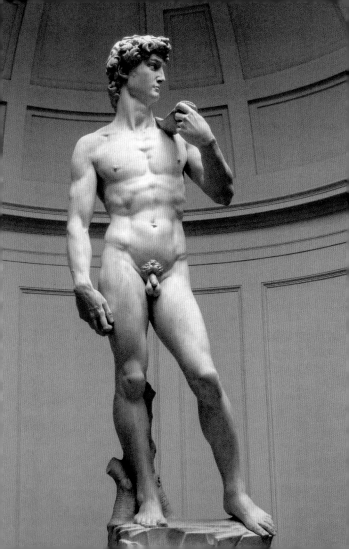

and knowing that he could not see properly, mount-
ed the scaffolding and taking his chisel dexterously
let a little marble dust fall on to the gonfaloniere,
without, however, actually altering his work.
Looking down he said, 'Look now.' 'I like it better,'
said the gonfaloniere, 'you have given it life.'
Michelagnolo therefore came down with feelings of
pity for those who wish to seem to understand mat-
ters of which they know nothing. When the statue
was finished Michelagnolo uncovered it. It certainly
bears the palm among all modern and ancient
works, whether Greek or Roman, and the Marforio
of Rome, the Tiber and Nile of Belvedere, and the
colossal statues of Montecavallo do not compare
with it in measure and beauty. The legs are finely
turned, the slender flanks divine, and the graceful
pose unequalled, while such feet, hands, and head
have never been excelled. After seeing this no one
need wish to look at any other sculpture or the work
of any other artist. Michelagnolo received four hun-
dred scudi from Piero Soderini, and it was set up in
1504.* Owing to his reputation thus acquired,

* The statue was moved to the Accademia, Florence, in 1873 and
replaced in its original position by a copy

Opposite: David ('the Giant'), 1501-4

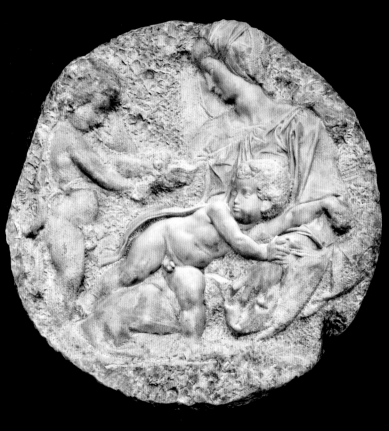

Michelagnolo did a beautiful bronze David* for the gonfaloniere, which he sent to France, and he sketched out two marble medallions, one for Taddeo Taddei, and now in his house,† the other for Bartolommeo Pitti, which was given by Fra Miniato Pitti of Monte Oliveto, a master of cosmography and many sciences, especially painting, to his intimate friend, Luigi Guicciardini.§ These works were considered admirable. At the same time he sketched a marble statue of St Matthew in the Opera of S. Maria del Fiore,‡ which showed his perfection and taught sculptors the way to make statues without spoiling them, by removing the marble so as to enable them to make such alterations as may be necessary. He also did a bronze Madonna in a circle, cast at the request of some Flemish merchants of the Moscheroni, noblemen in their country, who paid him one hundred scudi and sent it to Flanders.** His friend, Agnolo Doni, citizen of Florence, and the lover of all beautiful works whether ancient or modern, desired to have something of his. Michelagnolo

* Lost † Royal Academy, London § Bargello Museum, Florence
‡ Accademia, Florence ** In fact the marble group in Onze Lieve Vrouw, Bruges

Opposite: Virgin and Child with St John ('Taddei Tondo'), 1504-05

therefore began a round painting of the Virgin kneeling and offering the Child to Joseph, where he shows his marvellous power in the head of the mother fixedly regarding the beauty of the Child, and the emotion of Joseph in reverently and tenderly taking it.* As this did not suffice to display his powers, he made seated, standing, and reclining nude figures in the background, completing the work with such finish and polish that it is considered the finest of his few panel paintings. When finished he sent it still uncovered to Agnolo's house, with an officer and a request for seventy ducats as payment. Agnolo being a careful man, thought this a large sum, though he knew it was worth more. So he gave the bearer forty ducats, saying that was enough. Michelagnolo at once sent demanding one hundred ducats or the return of the picture. Andrea being delighted with the picture, then agreed to give seventy ducats, but Michelagnolo being incensed by Agnolo's mistrust, demanded double what he had asked the first time, and Agnolo, who wanted the picture, was forced to send him one hundred and forty scudi.

* Uffizi, Florence.

Opposite: Virgin and Child with St Joseph ("Doni Tondo"), 1503-4

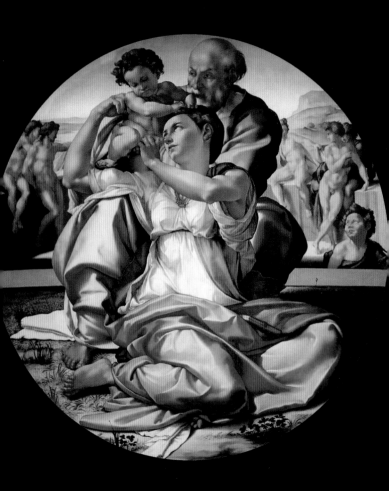

When Leonardo da Vinci was painting in the great hall of the council, as related in his *Life*, Piero Soderini, the gonfaloniere, allotted to Michelagnolo a part of that hall, for he perceived his great genius, and the artist chose the war of Pisa as his subject. He was given a room in the dyers' hospital at S. Onofrio, and there began a large cartoon, which he allowed no one to see. He filled it with nude figures bathing in the Arno owing to the heat, and running in this condition to their arms on being attacked by the enemy. He represented them hurrying out of the water to dress, and seizing their arms to go to assist their comrades, some buckling their cuirasses, and many putting on other armour, while others on horseback are beginning the fight. Among other figures is an old man wearing a crown of ivy to shade his head, trying to pull his stockings on to his wet feet, and hearing the cries of the soldiers and the beating of the drums he is struggling violently, all his muscles to the tips of his toes and his contorted mouth showing the effects of the exertion. It also contained drums and nude figures with bundles of clothes running to the fray, foreshortened in extraordinary attitudes, some upright, some kneeling, some

Opposite: Study for a bathing warrior at the Battle of Cascina, c. 1504-5

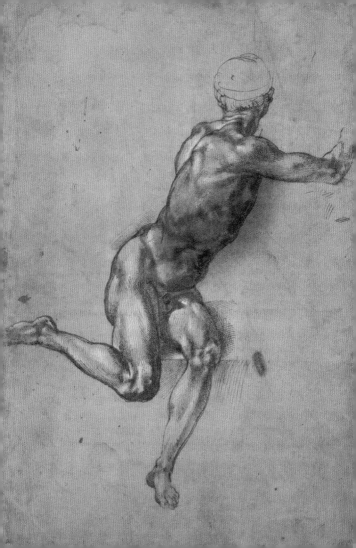

bent, and some lying. There were also many groups sketched in various ways, outlined in charcoal, designed with features, toned or with white lights to show his knowledge of art. And indeed artists were amazed when they saw the lengths he had reached in this cartoon. Some in seeing his divine figures declared that it was impossible for any other spirit to attain to its divinity. When finished it was, carried to the Pope's hall amid the excitement of artists and to the glory of Michelagnolo, and all those who studied and drew from it, as foreigners and natives did for many years afterwards, became excellent artists, as we see by Aristotile da Sangallo his friend, Ridolfo Ghirlandaio, Raphael Sanzio, Francesco Granacci, Baccio Bandinelli, Alonso Berruguette, a Spaniard, with Andrea del Sarto, Franciabigio, Jacopo Sansovino, Rosso, Maturino, Lorenzetto, Tribolo, then a child, Jacopo da Pontormo, and Perino del Vaga, all great Florentine masters. Having become a school for artists, this cartoon was taken to the great hall of the Medici palace, where it was entrusted too freely to artists, for during the illness of Duke Giuliano it was unexpectedly torn to pieces and scattered in many places, some fragments still being in the house of M. Uberto Strozzi, a Mantuan noble, who greatly values them, indeed

they are more divine than human*. The Pietà, the colossal statue, and the cartoon gave Michelagnolo such a name that when, in 1503, Julius II succeeded Alexander VI, he sent for the artist to make his tomb, paying him one hundred scudi for the journey. After reaching Rome, it was many months before he did anything. At last he settled on a design for the tomb, surpassing in beauty and richness of ornament all ancient and imperial tombs, affording the best evidence of his genius. Stimulated by this, Julius decided to rebuild St Peter's in order to hold the tomb, as related elsewhere. Michelagnolo set to work with spirit, and first went to Carrara to obtain all the marble, accompanied by two apprentices, receiving 1,000 scudi for this from Alamanno Salviati at Florence. He spent eight months there without receiving any further provision, his mind being full of projects for making great statues there as a memorial to himself, as the ancients had done, for he felt the fascination of the blocks. Having chosen his marble, he sent it by sea to Rome, where it filled half the piazza of St Peter's towards S. Caterina, and the space between the church and the corridor leading to Castello. Here Michelagnolo made his

* None of these fragments has survived, but there is a painted copy of the cartoon at Holkham Hall, Norfolk

studio for producing his figures and the rest of the tomb. In order that the Pope might readily come to see him work, he made a drawbridge from the corridor to the studio. His intimacy with the Pope afterwards brought him great annoyance and persecution, giving rise to much envy among artists. Of this work, during Julius's life and after his death, Michelagnolo did four complete statues, and sketched eight, as I shall relate. The work being devised with great invention, I will describe the ordering of it. Michelagnolo wished it to stand isolated, in order to make it appear larger, showing all four sides, twelve braccia on one, and eighteen for the other two. About it he arranged a series of niches separated by terminal figures clothed from the middle downwards and bearing the first cornice on their heads, each one having a nude prisoner in a curious attitude, and bound, resting on a projection from the basement. These prisoners were to represent the provinces subdued by the Pope and rendered obedient to the Church. Other statues, also bound, represented the sciences and fine arts doomed to death like the Pope who had protected them. At the corners of the first cornice were four

Opposite: The Rebellious Slave, c. 1513

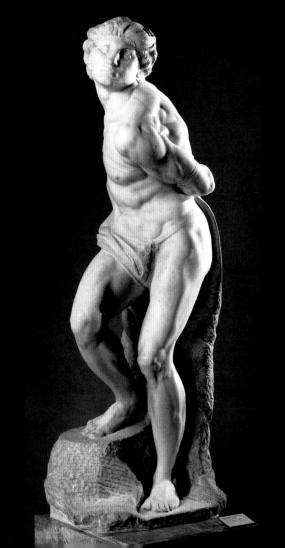

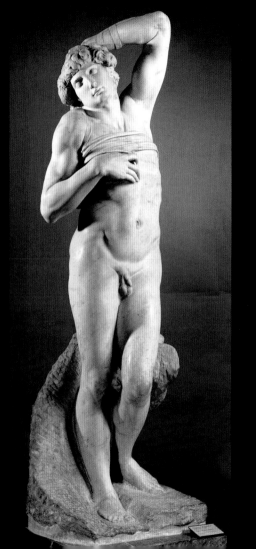

large figures, Active and Contemplative Life, St Paul and Moses. Above the cornice the work was on a smaller scale with a frieze of bronze bas-reliefs and other figures, infants and ornaments. As a completion there were two figures above, one a smiling Heaven, supporting the bier on her shoulders, with Cybele, goddess of the earth, who seems to grieve that the world has lost such a man, while the other rejoices that his soul has passed to celestial glory. There was an arrangement to enter at the top of the work between the niches, and an oval place to move about in the middle, like a church, in the midst of which the sarcophagus to contain the Pope's body was to be placed. In all it was to have forty marble statues without counting the reliefs, infants, and ornaments, the carved cornices and other architectural parts. For greater convenience Michelagnolo ordered that a part of the marble should be taken to Florence, where he proposed to spend the summer to escape from the malaria of Rome. There he completed one face of the work in several pieces, and at Rome divinely finished two prisoners and other statues which are unsurpassed. That they might not be otherwise employed, he gave the prisoners to Signor

Opposite: The Dying Slave, c. 1513

Ruberto Strozzi, in whose house Michelagnolo had fallen sick. They were afterwards sent to King Francis as a gift, and are now at Ecouen in France. He sketched eight statues at Rome, and five at Florence, and finished a Victory above a prisoner, now owned by Duke Cosimo, who had it from the artist's nephew Lionardo. The duke has placed it in the great hall of the palace painted by Vasari.*

Michelagnolo finished the Moses in marble,† a statue of five braccia, unequalled by any modern or ancient work. Seated in a serious attitude, he rests with one arm on the table, and with the other holds his long glossy beard, the hairs, so difficult to render in sculpture, being so soft and downy that it seems as if the iron chisel must have been a brush. The beautiful face, like that of a saint and mighty prince, seems as one regards it to need the veil to cover it, so splendid and shining does it appear, and so well has the artist presented in the marble the divinity with which God had endowed him. The draperies fall in graceful folds, the muscles of the arms and bones of

* The two finished *Slaves* are in the Louvre, Paris, and a further four unfinished ones are in the Accademia, Florence. The *Victory* is in the Palazzo della Signoria, Florence † S. Pietro in Vincoli, Rome

Opposite: Moses, c. 1515

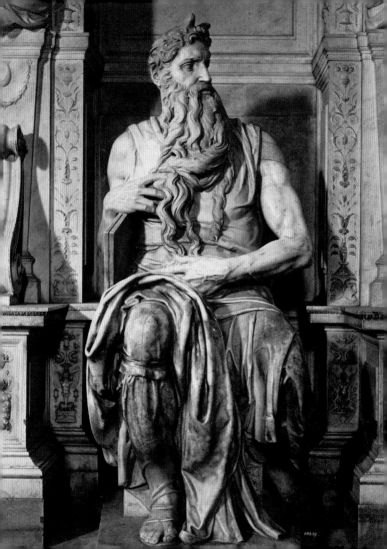

the hands are of such beauty and perfection, as are the legs and knees, the feet being adorned with excellent shoes, that Moses may now be called the friend of God more than ever, since God has permitted his body to be prepared for the resurrection before the others by the hand of Michelagnolo. The Jews still go every Saturday in troops to visit and adore it as divine, not a human thing. At length he finished this part, which was afterwards set up in S. Pietro in Vincoli.

It is said that while Michelagnolo was engaged upon it, the remainder of the marble from Carrara arrived at Ripa, and was taken with the rest to the piazza of St Peter's. As it was necessary to pay those who brought it, Michelagnolo went as usual to the Pope. But the Pope had that day received important news concerning Bologna, so Michelagnolo returned home and paid for the marble himself, expecting to be soon repaid. He returned another day to speak to the Pope, and found difficulty in entering; as a porter told him to wait, saying he had orders to admit no one. A bishop said to the porter, 'Perhaps you do not know this man.' 'I know him very well,' said the porter, 'but I am here to execute my orders.' Unaccustomed to this treatment, Michelagnolo told the man to inform the Pope he was away when next

his Holiness inquired for him. Returning home, he set out post at two in the morning, leaving two servants with instructions to sell his things to the Jews, and to follow him to Florence. Reaching Poggibonsi in Florentine territory, he felt safe, not being aware that five couriers had arrived with letters from the Pope with orders to bring him back. But neither prayers nor letters which demanded his return upon pain of disgrace moved him in the least. However, at the instance of the couriers, he at length wrote two words asking the Pope to excuse him, saying he would never return as he had been driven away, that his faithful service merited better treatment, and that he would find some one else to serve.

On reaching Florence, Michelagnolo finished in three months the cartoon of the great hall which Piero Soderini the gonfaloniere desired him to finish. The Signoria received at that time three letters from the Pope demanding Michelagnolo's return to Rome. On this account it is said that fearing the Pope's wrath he thought of going to Constantinople to serve the Turk by means of some Franciscan friars, from whom he learned that the Turk wanted him to make a bridge between Constantinople and Pera. However, Piero Soderini persuaded him to go to the Pope, and sent him as ambassador of

Florence, to secure his person, to Bologna, with let-
ters of recommendation to Cardinal Soderini, the
gonfaloniere's brother, who was charged to intro-
duce him to the Pope. There is another account of
this departure from Rome: that the Pope was angry
with Michelagnolo, who would not allow him to see
any of his things, and he suspected that the artist was
still in his house and working as had happened more
than once before. One day he had bribed the
apprentices to admit him to the chapel of his uncle
Sixtus, which he was having painted. Michelagnolo
had hidden himself, for he suspected the betrayal by
his apprentices, and threw down some planks as the
Pope entered the chapel, and not caring who it was,
caused the Pope to be summarily ejected. At all
events, whichever was the cause, he was angry with
the Pope, and also afraid of him.

Arrived at Bologna, he first approached the foot-
men and was taken to the palace of the Sixteen by a
bishop sent by Cardinal Salviati, who was sick. He
knelt before the Pope, who looked wrathfully at him,
and said as if in anger: 'Instead of coming to us, you
have waited for us to come and find you,' inferring
that Bologna is nearer Florence than Rome.
Michelagnolo humbly asked for pardon, saying he
had acted in anger through being driven away, and

that he hoped for forgiveness for his error. The bishop with him excused him, saying that such men are ignorant of everything except their art. At this the Pope waxed wroth, and striking the bishop with a mace he was holding, said: 'It is you who are ignorant, to reproach him when we say nothing.' The bishop therefore was dismissed with an usher, and the Pope's anger being appeased, he blessed Michelagnolo, who was loaded with gifts and promises, and ordered to prepare a bronze statue of the Pope, five braccia high, in a striking attitude of majesty, habited in rich vestments, and with determination and courage displayed in his countenance. This was placed in a niche above the S. Petronio gate.

It is said that while Michelagnolo was engaged upon it, Francia the painter came to see it, having heard much of him and his works, but seen none. He obtained the permission, and was amazed at Michelagnolo's art. When asked what he thought of the figure, he replied that it was a fine cast and good material. Michelagnolo, thinking that he had praised the bronze rather than the art, said: 'I am under the same obligation to Pope Julius, who gave it to me, as you are to those who provide your paints,' and in the presence of the nobles he angrily called him a blockhead. Meeting one day a son of

Francia, who was said to be a very handsome youth, he said: 'Your father knows how to make living figures better than to paint them.' One of the nobles asked him which was the larger, the Pope's statue or a pair of oxen, and he replied, 'In the matter of oxen, those of Bologna are certainly larger than our Florentine ones.' Michelagnolo finished the statue in clay before the Pope left for Rome; his Holiness went to see it, and asked if the raised right hand was giving a blessing or a curse. Michelagnolo answered that he was admonishing the people of Bologna to be prudent. When he asked the Pope whether he should put a book in his left hand, the pontiff replied, 'Give me a sword; I am not a man of letters.' The Pope left 1,000 scudi wherewith to finish it in the bank of M. Antonmaria da Lignano. After sixteen months of hard work it was placed over the door of the church of S Petronio, as already related. It was destroyed by the Bentivogli, and the bronze sold to Duke Alfonso of Ferrara, who made a cannon of it, called the Julius, the head only being preserved, which is now in his wardrobe.*

After the Pope had returned to Rome, and when Michelagnolo had finished the statue, Bramante, the

* Neither cannon nor head survives.

friend and relation of Raphael and therefore ill-disposed to Michelagnolo, seeing the Pope's preference for sculpture, schemed to divert his attention, and told the Pope that it would be a bad omen to get Michelagnolo to go on with his tomb, as it would seem to be an invitation to death. He persuaded the Pope to get Michelagnolo, on his return, to paint the vaulting of the Sistine Chapel. In this way Bramante and his other rivals hoped to confound him, for by taking him from sculpture, in which he was perfect, and putting him to colouring in fresco, in which he had had no experience, they thought he would produce less admirable work than Raphael, and even if he succeeded he would become embroiled with the Pope, from whom they wished to separate him. Thus, when Michelagnolo returned to Rome, the Pope had decided not to have the tomb finished, and asked him to paint the vaulting of the chapel. Michelagnolo tried every means to avoid it, and recommended Raphael, for he saw the difficulty of the work, knew his lack of skill in colouring, and wanted to finish the tomb. But the more he excused himself, the more the impetuous Pope was determined he should do it, being stimulated by the artist's rivals, especially Bramante. At length, seeing that the Pope was resolute, Michelagnolo decided to do it. The Pope

commanded Bramante to make preparations for the painting, and he hung a scaffold on ropes, making holes in the vaulting. When Michelagnolo asked why he had done this, as on the completion of the painting it would be necessary to do the holes again, Bramante declared there was no other way. Michelagnolo thus recognized either that Bramante was very ignorant or else hostile, and he went to complain to the Pope that the scaffolding would not do, and that Bramante did not know how it should be constructed. The Pope answered, in Bramante's presence, that Michelagnolo should design one for himself. Accordingly he erected one on poles not touching the wall, a method which guided Bramante and others in similar work. He gave so much rope to the poor carpenter who made it, that it sufficed, when sold, for the dower of the man's daughter, to whom Michelagnolo presented it. He then began the cartoons. The Pope wanted to destroy the work on the walls done by masters in the time of Sixtus, and he set aside 15,000 ducats as the cost, as valued by Giuliano da Sangallo. Impressed by the greatness of the work, Michelagnolo sent to Florence for help, resolving to prove himself superior to those who had worked there before, and to show modern artists the true way to design and paint. The circumstances

spurred him on in his quest of fame and his desire for the good of art. When he had completed the cartoons, he waited before beginning to colour them in fresco until his friends the painters should arrive from Florence, as he hoped to obtain help from them, and learn their methods of fresco painting, in which some of them were experienced, namely Granacci, Giulian Bugiardini, Jacopo di Sandro, Indaco the elder, Agnolo di Donnino, and Aristotile. He made them begin some things as a specimen, but perceiving their work to be very far from his expectations, he decided one morning to destroy everything which they had done, and shutting himself up in the chapel he refused to admit them, and would not let them see him in his house. This hard jest, as it seemed to them, drove them away, and they returned with shame and mortification to Florence. Michelagnolo thus undertook to do the whole work single-handed, and devoted to it the utmost pains and study, never allowing any one to see it upon any pretext, so that the utmost curiosity was excited. Pope Julius was very anxious to see his project, and the fact of its being hidden greatly excited his desire. But when he went one day he was not admitted. This led to the dispute already referred to, when Michelagnolo had to leave Rome. Michelagnolo has himself told me that when he had

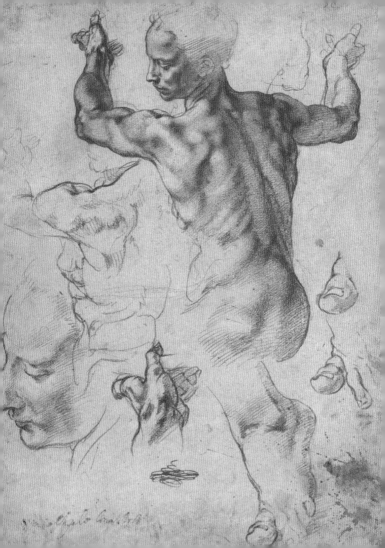

painted a third of the vault, a certain mouldiness began to appear one winter when the north wind was blowing. This was because the Roman lime, being white and made of travertine, does not dry quickly enough, and when mixed with pozzolana it becomes a tawny colour, making a dark mixture. If this mixture is liquid and watery, and the wall thoroughly wetted, it often effloresces in drying. This happened here, where the salt effloresced in many places, although in time the air consumed it. In despair at this, Michelagnolo wished to abandon the work, and when he excused himself, telling the Pope that he was not succeeding, Julius sent Giuliano da Sangallo, who explained the difficulty, and taught him how to obviate it. When he had finished half, the Pope, who sometimes went to see it by means of steps and scaffolds, wanted it to be thrown open, being an impatient man, unable to wait until it had received the finishing touches. Immediately all Rome flocked to see it, the Pope being the first, arriving before the dust of the scaffolding had been removed. Raphael, who was excellent in imitating, at once changed his style after seeing it, and to show his skill did the Prophets and Sybils in S. Maria della Pace, while Bramante tried to have the other half of the chapel given to Raphael.

Opposite: Study for the Libyan Sibyl (see p. 102), c. 1508

On hearing this Michelagnolo became incensed against Bramante, and pointed out to the Pope many faults in his life and works, the latter of which he afterwards corrected in the building of St Peter's. But the Pope daily became more convinced of Michelagnolo's genius, and wished him to complete the work, judging that he would do the other half even better. Thus, singlehanded, he completed the work in twenty months, aided only by his mixer of colours. He sometimes complained that owing to the impatience of the Pope he had not been able to finish it as he would have desired, as the Pope was always asking him when he would be done. On one occasion Michelagnolo replied that he would be finished when he had satisfied his own artistic sense. 'And we require you to satisfy us in getting it done quickly,' replied the Pope, adding that if it was not done soon he would have the scaffolding down. Fearing the Pope's impetuosity, Michelagnolo finished what he had to do without devoting enough time to it, and the scaffold being removed it was opened on All Saints' Day, when the Pope went there to sing mass amid the enthusiasm of the whole city. Like the old masters who had worked below, Michelagnolo wanted to retouch some things a *secco*, such as the backgrounds, draperies, the gold ornaments and

things, to impart greater richness and a better view. When the Pope learned this he wished it to be done, for he heard what he had seen so highly praised, but as it would have taken too long to reconstruct the scaffold, it was abandoned. The Pope often saw Michelagnolo, and said, 'Have the chapel enriched with colours and gold, in which it is poor.' He would answer familiarly, 'Holy Father, in those days they did not wear gold; they never became very rich, but were holy men who despised wealth.' Altogether Michelagnolo received 3,000 scudi from the Pope for this work, and he must have spent twenty-five on the colours. The work was executed in great discomfort, as Michelagnolo had to stand with his head thrown back, and he so injured his eyesight that for several months he could only read and look at designs in that posture. I suffered similarly when doing the vaulting of four large rooms in the palace of Duke Cosimo, and I should never have finished them had I not made a seat supporting the head, which enabled me to work lying down, but it so enfeebled my head and injured my sight that I feel the effects still, and I marvel that Michelagnolo supported the discomfort. However, his work made him want to do more every day, and he made such progress that he felt no fatigue, and despised the discomfort.

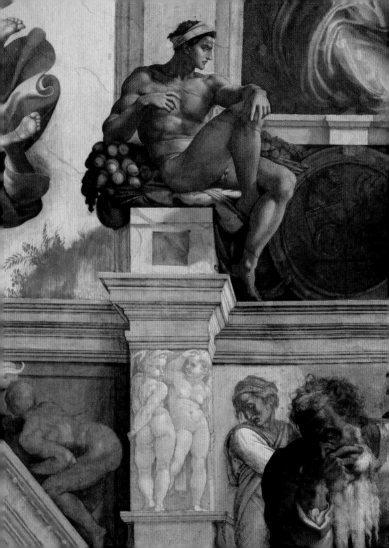

The work had six corbels at the sides and one at each end, containing sibyls and prophets, six braccia high, with the Creation of the World in the middle, down to the Flood and Noah's drunkenness, and the generations of Jesus Christ in the lunettes. He used no perspective or foreshortening, or any fixed point of view, devoting his energies rather to adapting the figures to the disposition than the disposition to the figures, contenting himself with the perfection of his nude and draped figures, which are of unsurpassed design and excellence. This work has been a veritable beacon to our art, illuminating all painting and the world which had remained in darkness for so many centuries. Indeed, painters no longer care for novelties in inventive attitudes and draperies, with new expressions and the force of things variously painted, because this work contains every perfection that can be given. Men are stupefied by the excellence of the figures, the perfection of the foreshortening, the stupendous rotundity of the contours, the grace and slenderness and the charming proportions of the fine nudes showing every perfection; every age, expression and form being represented in varied attitudes, such as sitting, turning, holding

Opposite: Ignudo from the Sistine Ceiling, Jeremiah below, 1509-12

89

The central section of the Sistine Ceiling, 1509-12

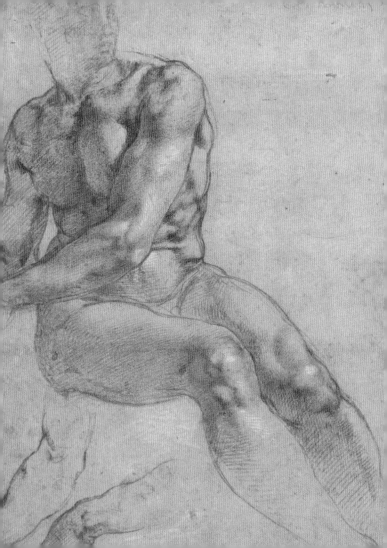

festoons of oak-leaves and laurel, the device of Pope Julius, showing that his was a golden age, for Italy had yet to experience her miseries. Some in the middle hold medals with scenes, painted like bronze or gold, the subject being taken from the Book of Kings. To show the greatness of God and the perfection of art he represents the Dividing of Light from Darkness, showing with love and art the Almighty, self-supported, with extended arms. With fine discretion and ingenuity he then did God making the sun and moon, supported by numerous cherubs, with marvellous foreshortening of the arms and legs. The same scene contains the blessing of the Earth and the creation of flying things, God being foreshortened, the figure following you to whatever part of the chapel you turn. In another part he did God dividing the Waters from the Land, marvellous figures showing the highest intellect and worthy of being made by the divine hand of Michelagnolo. He continued with the Creation of Adam, God being borne by a group of little angels, who seem also to be supporting the whole weight of the world. The venerable majesty of God with the motion as He surrounds some of the cherubs with

Opposite: Seated Young Male Nude and Two Arm Studies, c. 1510-11
Overleaf: Creation of Adam from the Sistine Ceiling, 1509-12

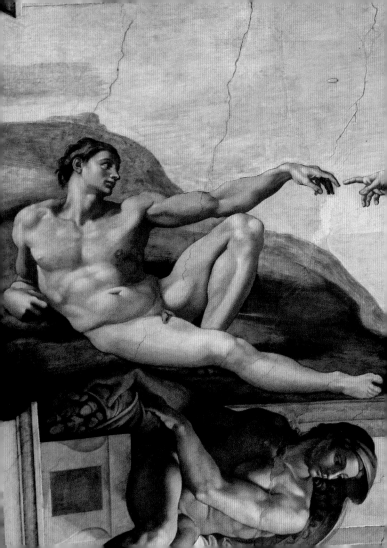

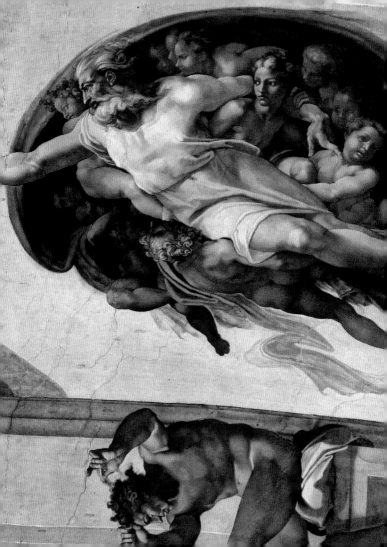

one arm and stretches the other to an Adam of mar-
vellous beauty of attitude and outline, seem a new
creation of the Maker rather than one of the brush
and design of such a man. He next did the Creation
of our Mother Eve, showing two nudes, one in a
heavy sleep like death, the other quickened by the
blessing of God. The brush of this great artist has
clearly marked the difference between sleeping and
waking, and the firmness presented by the divine
majesty, to speak humanly. He then did Adam eating
the apple, persuaded by a figure half-woman and
half-serpent, and he and Eve expelled from Paradise,
the angel executing the order of God with grandeur
and nobility, Adam showing at once grief for his sin
and the fear of death, while the woman displays
shame and a desire to obtain pardon, as she clasps
her arms and hands over her breast, showing, in turn-
ing her head towards the angel, that she has more
fear of the justice than hope of the divine mercy.
No less beautiful is the Sacrifice of Cain and Abel,
one bringing wood, one bending over the fire, and
some killing the victim, certainly not executed with
less thought and care than the others. He employed
a like art and judgment in the story of the Flood,
containing various forms of death, the terrified

Opposite: Creation of Eve from the Sistine Ceiling, 1509-12

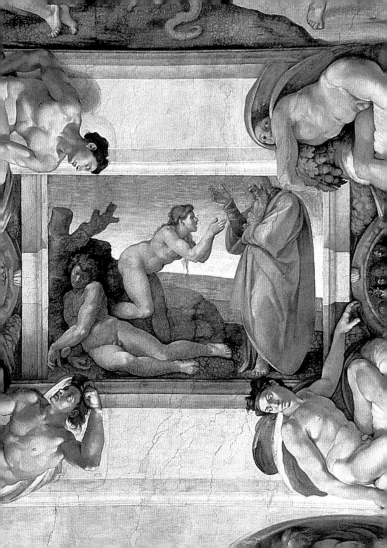

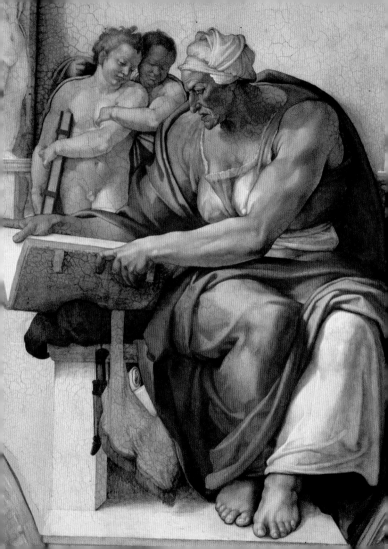

men trying every possible means to save their lives. Their heads show that they recognize the danger with their terror and utter despair. Some are humanely assisting each other to climb to the top of a rock ; one of them is trying to remove a half-dead man in a very natural manner. It is impossible to describe the excellent treatment of Noah's drunkenness, showing incomparable and unsurpassable art. Encouraged by these he attacked the five sibyls and seven prophets, showing himself even greater. They are of five braccia and more, in varied attitudes, beautiful draperies, and displaying miraculous judgment and invention, their expressions seeming divine to a discerning eye. Jeremiah, with crossed legs, holds his beard with his elbow on his knee, the other hand resting in his lap, and his head being bent in a melancholy and thoughtful manner, expressive of his grief, regrets, reflection, and the bitterness he feels concerning his people. Two boys behind him show similar power; and in the first sibyl nearer the door, in representing old age, in addition to the involved folds of her draperies, he wishes to show that her blood is frozen by time, and in reading she holds the book close to her eyes, her sight having failed. Next comes Ezekiel, an old man with

Opposite: The Cumaean Sibyl from the Sistine Ceiling, 1509-12

fine grace and movement, in copious draperies, one hand holding a scroll of his prophecies, the other raised as if he wished to declare things high and great. Behind him are two boys holding his books. Next comes a sibyl, who, unlike the Erythraean sibyl just mentioned, holds her book at a distance, and is about to turn the page; her legs are crossed, and she is reflecting what she shall write, while a boy behind her is lighting her lamp. This figure has an expression of extraordinary beauty, the hair and draperies are equally fine, and her arms are bare, and as perfect as the other parts. He did next the Joel earnestly reading a scroll, with the most natural expression of satisfaction at what he finds written exactly like one who has devoted close attention to some subject. Over the door of the chapel Michelagnolo placed the aged Zachariah, who is searching for something in a book, with one leg raised and the other down, though in his eager search he does not feel the discomfort. He is a fine figure of old age somewhat full, his fine drapery falling in few folds. There is another sibyl turned towards the altar showing writings, not less admirable with her boys than the others. But for Nature herself one must see the Isaiah, a figure wrapped in thought, with his legs crossed, one hand

Opposite: The Prophet Isaiah from the Sistine Ceiling, 1509-12

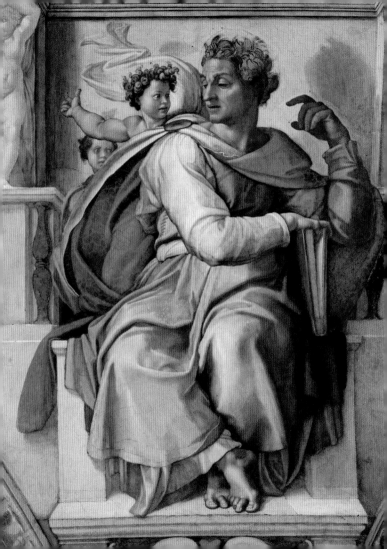

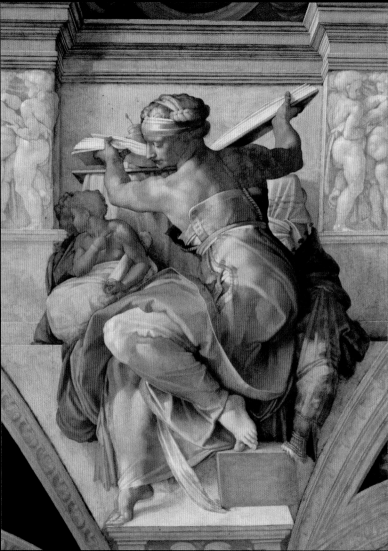

on his book to keep the place, and the elbow of the other arm also on the volume, and his chin in his hand. Being called by one of the boys behind, he rapidly turns his head without moving the rest of his body. This figure, when well studied, is a liberal education in the principles of painting. Next him is a beautiful aged sibyl, who sits studying a book, with extraordinary grace, matched by the two boys beside her. It would not be possible to add to the excellence of the youthful Daniel, who is writing in a large book, copying with incredible eagerness from some writings, while a boy standing between his legs supports the weight as he writes. Equally beautiful is the Libyan sibyl, who having written a large volume drawn from several books, remains in a feminine attitude ready to rise and shut the book, a difficult thing practically impossible for any other master. What can I say of the four scenes in the angles of the corbels of the vaulting? A David stands with his boyish strength near a giant, while soldiers about the camp marvel. Very wonderful are the attitudes in the story of Judith, in which we see the headless trunk of Holofernes, while she puts the head into a basket carried by her old attendant, who being tall bends

Opposite: The Libyan Sybil from the Sistine Ceiling, 1509-12
Overleaf: Judith and Holofernes from the Sistine Ceiling, 1509-12

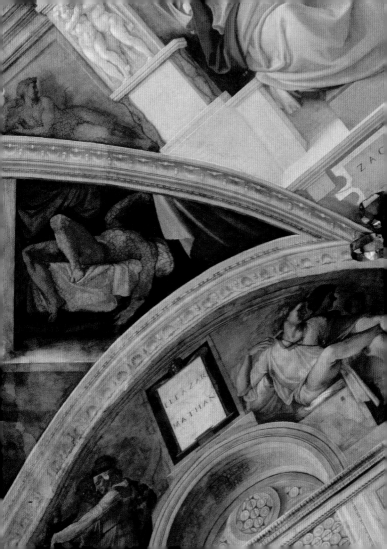

down to permit Judith to do it, while she prepares to cover it, and turning towards the trunk shows her fear of the camp and of the body, a well-thought-out painting. Finer than this and than all the rest is the story of the Brazen Serpent, showing the death of many, the biting of the serpents, and Moses raising the brazen serpent on a staff, with a variety in the manner of death and in those who being bitten have lost all hope. The keen poison causes the agony and death of many, who lie still with twisted legs and arms, while many fine heads are crying out in despair. Not less beautiful are those regarding the serpent, who feel their pains diminishing with returning life. Among them is a woman, supported by one whose aid is as finely shown as her need in her fear and distress. The scene of Ahasuerus in bed having the annals read to him is very fine. There are three figures eating at a table, showing the council held to liberate the Hebrews and impale Haman, a wonderfully foreshortened figure, the stake support-ing him and an arm stretched out seeming real, not painted, as do his projecting leg and the parts of the body turned inward. It would take too long to enu-merate all the beauties and various circumstances in

Opposite: Studies for Haman, 1511-12

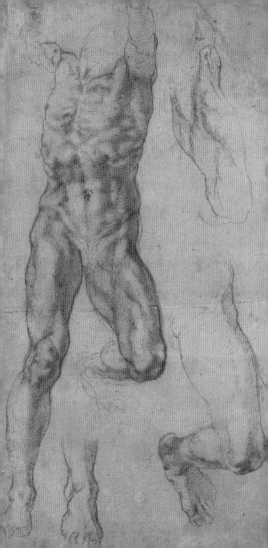

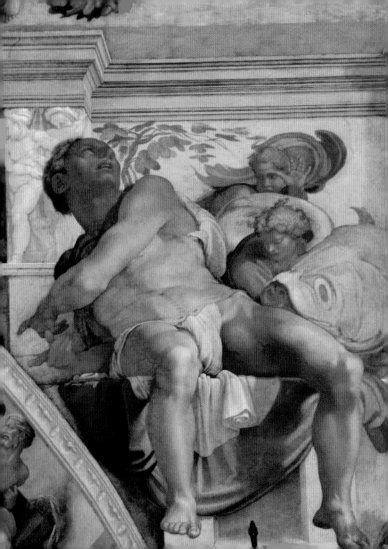

the genealogy of the patriarchs, beginning with the sons of Noah, forming the generation of Christ, containing a great variety of draperies, expressions, extraordinary fancies; nothing in fact but displays genius, all the figures being finely foreshortened, and everything being admirable and divine. But who can see without wonder the Jonah, the last figure of the chapel?—his face, issuing from the wall, seems a veritable triumph of art, design, light, and shade. Oh, happy age! oh, blessed artists who have been able to refresh your darkened eyes at the fount of such clearness, and see difficulties made plain by this marvellous artist! His labours have removed the bandage from your eyes, and he has separated the true from the false which clouded the mind. Thank heaven, then, and try to imitate Michelagnolo in all things.

When the work was uncovered every one rushed to see it from every part and remained dumfounded. The Pope being thus encouraged to greater designs, richly rewarded Michelagnolo, who sometimes said in speaking of the great favours showered upon him by the Pope, that he fully recognized his powers, and if he sometimes used hard words, he healed them by

Opposite: Jonah, Sistine Ceiling, 1509-12

signal gifts and favours. Thus, when Michelagnolo once asked leave to go and spend the feast of St John in Florence, and requested money for this, the Pope said, 'When will this chapel be ready?' 'When I can get it done, Holy Father.' The Pope struck him with his mace, repeating, 'When I can, when I can, I will make you finish it!' Michelagnolo, however, returned to his house to prepare for his journey to Florence, when the Pope sent Cursio, his chamberlain, with five hundred scudi to appease him and excuse the Pope, who feared what Michelagnolo might do. As Michelagnolo knew the Pope, and was really devoted to him, he laughed, especially as such things always turned to his advantage, and the Pope did everything to retain his goodwill.

On the completion of the chapel the Pope directed Cardinal Santiquattro and Cardinal Aginense, his nephews, to have his tomb finished on a smaller scale than at first proposed. Michelagnolo readily began it anew, hoping to complete it without the hindrance which afterwards caused him so much pain and trouble. It proved the bane of his life, and for some time made him appear ungrateful to the Pope, who had so highly favoured him. On returning to the tomb he worked ceaselessly upon designs for the walls of the chapel; but envious fortune

would not allow him to complete the monument he had begun so superbly, for the death of Julius occurred then. It was abandoned at the election of Leo X, a pope of no less worth and splendour, who, being the first Florentine pope, desired to adorn his native city with some marvel executed by a great artist, and worthy of his position. Accordingly he directed Michelagnolo to prepare designs for the façade of S. Lorenzo, the church of the Medici at Florence, if he was to direct the work, and so the tomb of Julius was abandoned. When Michelagnolo made every possible objection, saying that he was under obligation to Santiquattro and Aginense, Leo replied that he had thought of this, and had induced them to release him, promising that Michelagnolo should do the figures for the tomb at Florence. But this caused great dissatisfaction to the cardinals and Michelagnolo, who departed weeping.

Endless disputes now arose, because the façade should have been divided among several persons. Moreover many artists flocked to Rome, and designs were prepared by Baccio d'Agnolo, Antonio da Sangallo, Andrea and Jacopo Sansovino, the gracious Raphael of Urbino, who afterwards went to Florence with the Pope for the purpose. Michelagnolo therefore determined to make a model, not

acknowledging any superior or guide in architecture. But his resolve to do without help led to the inactivity of himself and the other masters, who in despair returned to their accustomed avocations. Michelagnolo went to Carrara with a commission to receive 1,000 scudi from Jacopo Salviati. But Jacopo being closeted in a room with some citizens on certain affairs, Michelagnolo would not wait, but left at once for Carrara without a word. On hearing of Michelagnolo's arrival, Jacopo, who could not find him in Florence, sent the 1,000 scudi to Carrara. He ordered the messenger to bring a receipt, but Michelagnolo said that he was working for the Pope and not for himself, and it was not his practice to give receipts, so that the messenger returned without one. While Michelagnolo was at Carrara selecting marble for the façade and also for the tomb of Julius, which he hoped to finish, he received a letter from Leo, who had heard that the highest mountain of the Petra Santa range at Seravezza in Florentine territory contained marble of equal beauty and excellence to that of Carrara. Michelagnolo knew as much before but did not wish to take note of it, because he was friendly with the Marquis Alberigo, lord of Carrara, and perhaps he thought he would lose time. However, he was forced to go to

Seravezza, although he declared it would involve more trouble and expense, especially at the beginning. But the Pope would not listen, and it was necessary to make a road of several miles through the mountains, breaking the rocks with maces and pickaxes, and driving piles in the marshy places. In fulfilling the Pope's wish Michelagnolo thus spent many years, and at length obtained five columns of some size, one of which is on the piazza of S. Lorenzo at Florence, the others being on the coast. Marquis Alberigo, seeing himself abandoned, became very hostile to Michelagnolo, though it was not his fault. He quarried much marble in addition, which has remained there for more than thirty years. But Duke Cosimo has directed the completion of the road, two awkward miles still being left to do, to have this marble brought, and also from another quarry discovered by Michelagnolo, to finish numerous undertakings. In the same place Michelagnolo discovered a hard and beautiful variegated marble under Stazema, between which and the sea Duke Cosimo has made a road of more than four miles. To return to Michelagnolo. He returned to Florence after wasting much time first on one thing and then on another, and made a model for the projecting windows of the corner rooms of the Medici palace,

where Giovanni da Udine decorated a chamber with painting and stucco. He directed the making of perforated copper jalousies, executed by Piloto the goldsmith, which are certainly admirable. He spent many years in quarrying marble, though meanwhile he made more models and other things for the work. However, it dragged on so long that the money appointed for it by the Pope was consumed by the war in Lombardy, and it was unfinished at Leo's death, the foundations being laid and a large marble column brought from Carrara to the piazza of S. Lorenzo. The death of Leo so astounded the artist and the arts both in Rome and Florence, that during the life of Hadrian VI Michelagnolo devoted himself in Florence to the tomb of Julius. But when Hadrian was succeeded by Clement VII, who proved himself as eager as Leo to earn renown in architecture, painting, and sculpture, Giorgio Vasari, then a child, was taken from Florence in 1525 by the Cardinal of Cortona, and put to learn art with Michelagnolo. But as the latter was summoned to Rome by the Pope to begin the library of S. Lorenzo and the new sacristy to contain the Medici tombs, he decided that Vasari should go to Andrea del Sarto, and so he took him to Andrea's shop himself. Michelagnolo left for Rome in haste, being

tormented by Francesco Maria, Duke of Urbino, nephew of Pope Julius, who complained of the artist, saying that he had received 16,000 scudi for the tomb while he amused himself in Florence, and threatening him if he did not devote his attention to it. When he reached Rome Pope Clement advised him to make an account with the duke's agent, when it seemed likely that he would be found to be the creditor rather than the debtor by what he had done, and so the matter rested, and it was decided to finish the sacristy and new library of S. Lorenzo at Florence. Accordingly Michelagnolo left Rome, and vaulted the cupola, getting Piloto the goldsmith to make a ball with seventy-two faces, and of great beauty. While it was building some friends said, 'You ought to make your lantern quite different from Brunelleschi's.' To which he replied, 'I might make alterations, but not improvements.' He introduced four tombs for the bodies of the fathers of the two popes, Lorenzo the elder and his brother Giuliano, and for Giuliano, Leo's brother, and Duke Lorenzo, his nephew. He proposed to imitate the old sacristy of Brunelleschi, but with other ornaments. He introduced a varied and more novel composition than ancient and modern masters have been able to employ, for his fine corners, capitals, bases, doors,

tabernacles, and tombs vary considerably from the common rule, and from the lines laid down by Vitruvius and the ancients. This licence has encouraged others to imitate him, and new fancies have sprung up, more like grotesques than regular ornament. Artists however owe Michelagnolo a great debt for having broken the chains which made them all work in one way. He showed it even better in the library of S. Lorenzo, in the handsome disposition of the windows and ceiling, and the marvellous vestibule. Nothing so graceful and vigorous in every part was ever seen, comprising the bases, tabernacles, corners, convenient staircase with its curious divisions, so different from the common treatment as to excite general wonder. At that time he sent Pietro Urbano of Pistoia, a pupil, to Rome, to begin a naked Christ bearing the cross, a marvellous figure placed next the principal chapel in the Minerva by M. Antonio Metelli.*

After the Sack of Rome and the expulsion of the Medici from Florence, the government appointed Michelagnolo to be controller-general of all the fortifications, and he designed fortifications for the city, and surrounded the hill of S. Miniato with

* S. Maria sopra Minerva, Rome.

bastions, not only earthworks with the usual fascines, but with a framework below of oaks and chestnuts and other good materials, using rough bricks carefully levelled. The Signoria of Florence sent him to Ferrara to see the fortifications of Duke Alfonso and his artillery and munitions. The duke received him very graciously, and begged him to do something for him. Michelagnolo promised, and although he was constantly engaged on his return in fortifying the city, he did a divine Leda* in tempera for the duke, and laboured secretly on the statues for the tombs of S. Lorenzo. He remained some six months on the hill of S. Miniato to superintend the fortifications, for if the enemy could take it, the city was lost, and so he applied all his diligence to the work.

At this time he did seven statues for the sacristy, some finished and some not. In this as in the architecture it must be admitted that he surpassed every one in the three professions. Among the statues there, there is a Madonna with her legs crossed, and the child, who is seated astride the upper knee, is turning round in a charming attitude to his mother's breast. The mother holds him with one hand, and supporting herself with the other, prepares to satisfy

* Lost, although copies survive.

him. Although unfinished, the perfection of the work is apparent. Much greater wonder was excited by the tombs of the Medici. Thinking the earth alone insufficient for their greatness, he wished to unite all the powers of the world, and adorn their tomb with four statues, Night and Day on one, and Dawn and Twilight on the other. They are executed in wonderful attitudes, the muscles being made in a way that would have restored the art to splendour if it had been lost. He did two other statues of the princes in armour, Duke Lorenzo in thoughtful pose, his legs being the finest imaginable. The other is Duke Giuliano with bold head and throat, deep-set eyes, prominent nose, half-open mouth, divine hair, hands, knees, and feet, so that the eye never wearies of regarding them. Indeed his cuirass and buskins seem divine and not mortal. What shall I say of the nude female Dawn with her melancholy spirit, showing her desire to rouse from sleep, as she seems to have found on rising that the duke's eyes are closed for ever, and so she displays the greatest grief? What shall I say also of the unique Night? What century, ancient or modern, has ever seen such

*Opposite: Tomb of Giuliano de' Medici, with the statues of
Night and of Day, 1519-33*

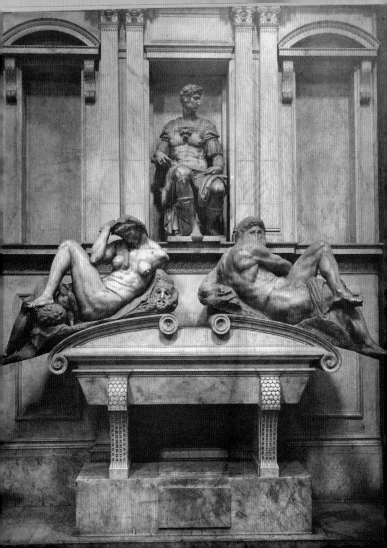

statues, showing not only the quiet of the sleeper, but the sorrow of one who has lost something noble and great? This Night has been supposed to have obscured all those who for some time sought, not to surpass it, but to equal it. The figure displays the somnolence of those who sleep. Thus many learned persons made Latin verses and rhymes in the vernacular in its praise, such as the following, the author of which is not known :—

> *La Notte che tu vedi in si dolce atti*
> *Dormire, fu da un angelo scolpita*
> *In quello sasso; e perche dorme ha vita;*
> *Destala, se no'l credi, e parleratti.* *

To this Michelagnolo, in the person of his Night, replied :—

> *Grato m'è 'l sonno, e più l'esser di sasso*
> *Mentre che 'l danno e vergogna dura,*

* 'The Night which thou seest sleeping in such grateful pose, was chiselled by an angel in this stone; though asleep she lives; rouse her if thou dost not believe, and she will speak to thee.' Now known to be by G. B. Strozzi

Opposite: Studies for Night, c. 1524-1525. For verso, see p. 122

Non veder non sentir, m'è gran ventura;
*Però non mi destar: deh parla basso.**

If the hostility of Fortune and Genius had allowed him to complete this, Art might have shown Nature how much she surpassed her in every thought. While Michelagnolo was engaged upon this work with love and care, the siege of Florence took place in 1529, so that he could do little or nothing more, as the citizens had given him the charge of the fortifications. He had lent the republic 1,000 scudi, and was one of the Nine of the militia, a council of war, and so he devoted all his powers to perfecting the defences. After the investment was completed, when all hope of aid had disappeared, and the difficulty of the defence increased, he decided to leave Florence for Venice secretly, to secure his personal safety. Accordingly he slipped out by way of S. Miniato, taking with him his pupil Antonio Mini and Piloto the goldsmith, his faithful friend, each of them carrying a number of scudi fastened in their

* 'Sweet is sleep to me, and being of stone even more so, while loss and shame endure. Not to see nor feel is a most happy chance, therefore do not rouse me, hush! speak soft.'

Opposite: Study for Day, c. 1524-5; verso of the studies for Night on p. 121

doublets. At Ferrara they found that, owing to the suspicions of war time and the league of the Pope and Emperor against Florence, Duke Alfonso was keeping himself secretly informed by the innkeepers of the names of all those who stayed with them, and had the list of foreigners with their nationality brought to him every day, and thus he learned of the presence of Michelagnolo and his friends, though they did not want to be known, and rejoiced greatly, because he had become his friend. Alfonso was a magnanimous prince and a patron of genius all his life long. He immediately sent some of the first men of his court to bring Michelagnolo to the palace with his horses and all his things and provide them with good, quarters there. Michelagnolo was forced to obey, and to give what he could not sell, and he went with them to the duke without removing his things from the inn. The duke received him very graciously, but complained of his reserve, and then by making him rich presents tried to detain him in Ferrara, with a good provision. But Michelagnolo would not remain, though the duke begged that he would at least stay during the war, and made him munificent offers. Unwilling to be surpassed in courtesy, Michelagnolo thanked the duke, and turning to his companions, said he had brought 12,000 scudi to

Ferrara, which he placed at the duke's disposal. The duke then took him through the palace, as he had done before, showing him his treasures, including a portrait of himself by Titian, which Michelagnolo highly praised. But he would not remain in the palace, deciding to return to the inn. The host was strictly enjoined to do them great honour, and to take nothing for their entertainment.

Michelagnolo then went to Venice, where he wished to make the acquaintance of several nobles. But seeing that they knew little of art, he left the Giudecca where he lodged, and where he is said to have designed the original and ornate Rialto bridge, at the prayers of the Doge Gritti. But he was earnestly entreated to return to his country, though they begged him not to abandon the undertaking, and sent him a safe-conduct. At length, conquered by love of his native place, he returned, not without peril of his life, and meanwhile finished the Leda for Duke Alfonso, which was afterwards taken to France by his pupil Antonio Mini. He repaired the campanile of S. Miniato, a tower which had caused much annoyance to the enemy's camp by its two pieces of artillery. They had attacked it with heavy cannon, inflicting much damage, and would have destroyed it. Michelagnolo fortified it with large

bales of wool and strong mattresses and ropes, so that it is still standing. It is said that during the siege he had the opportunity of fulfilling an earlier desire to do a marble block from Carrara of nine braccia, which Pope Clement had given to Baccio Bandinelli after both had asked for it. As it was public property, Michelagnolo asked the gonfaloniere for it, and so obtained it, although Baccio had made a model and had knocked away much of the stone. Michelagnolo also made a model which was considered marvellous, but on the restoration of the Medici the block was again given to Baccio.

After the settlement Baccio Valori, the papal commissary, was commissioned to imprison in the Bargello some of the most deeply implicated citizens. The court sent to Michelagnolo's house, but the artist's suspicions were aroused, and he had fled to a friend, with whom he remained hidden for several days. At length, after the first heat, Clement remembered the genius of Michelagnolo, and sought diligently for him, promising that nothing should be said, that he should receive his former provisions and his work at S. Lorenzo. For this he appointed Giovambatista Figiovanni as provveditore, an old servant of the Medici and prior of S. Lorenzo. Thus reassured, Michelagnolo began a

marble Apollo of three braccia drawing an arrow from his quiver, to win the friendship of Baccio Valori, and almost completed it. It is now in the chamber of the Prince of Florence, a most rare work although not quite finished.*

At this time Duke Alfonso of Ferrara, having learned that Michelagnolo had produced a remarkable work, and being anxious not to lose such a jewel, sent a nobleman to Florence with letters of credit. Michelagnolo received him courteously, and showed him his Leda embracing the Swan with Castor and Pollux issuing from the egg, a large picture painted in tempera. The duke's envoy expecting from Michelagnolo's great reputation that he would have done something great, and not perceiving the excellence of the work, exclaimed, 'This is a small thing.' Michelagnolo asked what his profession was, for he knew that those who practises a thing are best qualified to pass judgment on it. The envoy replied, 'I am a merchant,' thinking that Michelagnolo did not know him to be a noble, and as it were mocking at such a question and despising the industry of the

* Bargello Museum, Florence

Overleaf: The Holy Family with St John the Baptist, c. 1530

Florentines. Michelagnolo, who well knew what he meant, said, 'You will have done bad business for your master this time; begone!' Then, as his pupil Antonio Mini had two sisters to marry, and asked his master for the picture, Michelagnolo gave it to him readily, together with the greater part of his divine designs and cartoons, and with two chests of models, with a large number of finished cartoons for painting, and some of work done. Antonio having then the fancy to go to France, took them with him and sold the Leda to King Francis. It is now at Fontainebleau. The cartoons and designs suffered a sad fate, for Anton died there in a little while, and they were stolen, an irreparable loss to the country, depriving it of such useful labours. The cartoon of Leda*, however, has returned to Florence, and Bernardo Vecchietti has it, while four pieces of the cartoon of the chapel, of nudes and prophets,† bought by Benvenuto Cellini the sculptor, are now owned by the heirs of Girolamo degli Albizzi. Michelagnolo decided to visit Pope Clement at Rome, and the pontiff, as the friend of genius, though much incensed against him, pardoned him everything, and ordered him to return to Florence to

* Lost † Lost

finish the library and sacristy of S. Lorenzo. To shorten the work he divided a number of the statues among other masters, allotting two to Tribolo, one to Raffaello da Montelupo, and one to Fra Agnolo the Servite, while he helped them by making the clay models. So all worked bravely, while Michelagnolo devoted himself to the library, finishing the carved wooden ceiling with models made by the Florentines Carota and Tasso, both excellent carvers and masters. The bookshelves were done by Battista del Cinque and Ciapino his friend, both good masters. To finish it Giovanni da Udine was brought to Florence, who with his Florentine assistants decorated the tribune with stucco, so that all felt eager to finish the task. Just as Michelagnolo was proposing to begin the statues, the Pope was seized with a desire to have the walls of the Sistine Chapel painted with a Last Judgment, to show the powers of the art of design, and on the opposite wall he wanted to have Lucifer cast down from heaven with the rebel angels. Michelagnolo had made sketches for these ideas long before, one of which was executed in the Trinità at Rome by a Sicilian painter, who had served Michelagnolo many months and ground his colours. This work in the crossing of the church at the chapel of St Gregory, although badly executed,

possesses a certain wonderful power in the varied attitudes and groups of nudes raining from heaven, and converted into terrible devils on reaching the earth, a curious fancy.

While Michelagnolo was busy with his designs for the Judgment, the agents of the Duke of Urbino assailed him daily for having received 16,000 scudi for the tomb of Julius II. Although he was now old Michelagnolo would willingly have finished it had the opportunity occurred, for he would gladly have been at Rome and never returned to Florence, fearing Duke Alessandro, who bore him little love. For when the duke sent Sig. Alessandro Vitelli to consult him upon the best site for the citadel of Florence, he refused to go unless commanded by Pope Clement. At length an arrangement was made concerning the tomb, that it should not be made square, but with one side only, as Michelagnolo should determine, and that he should introduce six statues by his own hand. The Duke of Urbino granted him permission to serve the Pope for four months of the year, in Florence or elsewhere. But although Michelagnolo believed the matter to be settled, it was not, for Clement, eager to see the full extent of his powers, desired him to devote himself to the cartoon of the Judgment. But though he showed the Pope that he

was occupied upon it, he was secretly engaged upon the statues for the tomb.

On the death of Clement in 1533 the work of the sacristy and library at Florence was stopped, in spite of the efforts to finish it. Michelagnolo then thought himself free at length to devote his energies to the tomb of Julius. But the new pope, Paul III, soon summoned him and required his services, offering him gifts and favours, and wanted him to remain near his person. Michelagnolo, however, declined until the tomb should be finished, alleging his contract with the Duke of Urbino. His refusal angered the Pope, who said, 'I have been longing for this opportunity for thirty years, and shall I not have it now I am Pope? I will tear up the contract, and I am determined that you shall serve me, come what may.' Michelagnolo, seeing his determination, was tempted to leave Rome and find some means of finishing the tomb elsewhere. However, he had a prudent fear of the Pope, and thought that he would satisfy him with words, for Paul was very old, and await his opportunity.

The Pope, who wished to employ Michelagnolo on some noteworthy work, one day called at his house with ten cardinals. He saw and admired all the statues for the tomb of Julius, especially the

Moses which the Cardinal of Mantua declared sufficient by itself to honour the dead pope. The Pope also saw the cartoons for the walls of the chapel, which he thought stupendous, and again besought him to serve him, promising that he would persuade the Duke of Urbino to rest content with three statues if the others were made from Michelagnolo's models by excellent masters. Accordingly, by means of the Pope, Michelagnolo made a new contract with the Duke's agents, binding himself to do three statues, depositing 1,580 ducats in the bank of the Strozzi, though he might have avoided it. He thought he had done enough to acquit himself of this long and harassing task, which was executed in the following manner in S. Pietro in Vincoli.

He made a carved basement with four projections, each with a figure representing a prisoner, as at first arranged, but for which a caryatid was substituted. On each base he placed a corbel upside down to relieve the poverty of the lower part. Between the caryatids were three niches, originally intended for Victories. Instead he put Leah, Laban's daughter, in one, for Active Life, holding a mirror to show the consideration necessary for action. In another he put

Opposite: The Julius tomb as completed, 1547

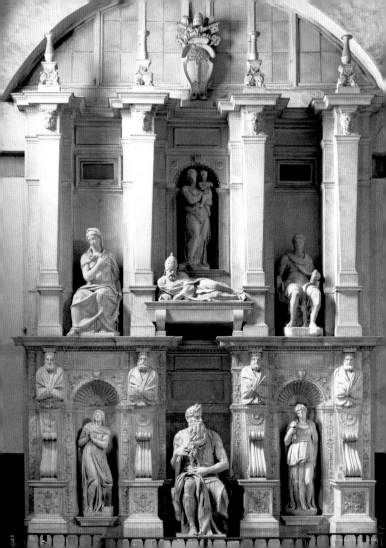

a garland of flowers for the virtues that adorn life and render it glorious after death. The third contained Rachel, Leah's sister, for Contemplative Life, her hands clasped, one knee bent, and her face raised to heaven, as if in ecstasy. Michelagnolo executed these statues himself in less than a year. In the middle niche, which was square, he originally proposed to make one of the doors into the tomb. He afterwards converted it into a niche, and placed there the magnificent statue of Moses, already sufficiently described. The caryatids, whose heads serve as capitals, bear the architraves, frieze, and cornice, projecting above them, carved with rich foliage, ovals, denticulations, and other rich ornaments. Above the cornice is another order without carving, with other and different caryatids immediately above the first, like pilasters, with variously moulded cornices, the whole corresponding to what is below. The space corresponding to that occupied by the Moses has a marble sarcophagus, with the recumbent statue of Pope Julius made by Maso dal Bocco the sculptor. The right-hand niche contains a Virgin and Child by Scherano da Settignano the sculptor, from Michelagnolo's model, both statues of merit. The niches above those containing the Active and Contemplative Life contain two larger seated statues

of a Prophet and a Sibyl, executed by Raffaello da Montelupo, as related in the *Life* of his father Baccio, which were not done to Michelagnolo's satisfaction. Above the whole was a richly decorated projecting cornice, with marble candelabra above the caryatids, the arms of Pope Julius in the middle, and a window above the Prophet and Sibyl for the convenience of the friars of the church, the choir being behind, to permit the voices to penetrate to the church, and to allow the office to be seen. Indeed, the work has succeeded excellently, though it is very different from the original design.

As he had no choice, Michelagnolo decided to serve Paul, who wished him to continue what had been ordained by Clement without altering anything, for the Pope bore such love and admiration for that artist that he only sought to please him. Thus when Paul desired to put his arms under Jonah, where those of Julius had been, Michelagnolo objected that it was not well to wrong the memory of Julius and Clement, and the Pope respected the man who meant to be just without adulation, a thing princes rarely experience.

For the wall of the chapel, Michelagnolo made a shield of well-baked and carefully chosen bricks to project half a braccia from the top of the chapel, so

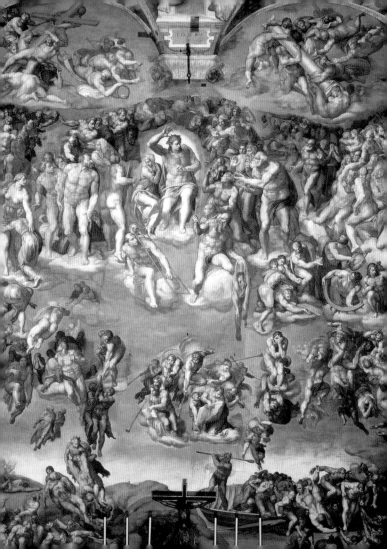

that no dust or other soil could lodge on the work. I will not enter into the particulars of the invention or composition of this scene, as it has been so often copied and printed in all sizes that it would be a waste of time. Suffice it to say that the purpose of this remarkable man was none other than to paint the most perfect and well-proportioned composition of the human body in the most various attitudes, and to show the emotions and passions of the soul, displaying his superiority to all artists, his great style, his nudes, and his knowledge of the difficulties of design. He has thus facilitated art in its principal object, the human body, and in seeking this end alone he has neglected charming colouring, fancies, new ideas with details and elegances which many other painters do not entirely neglect, perhaps not without reason. Thus some, not so grounded in design, have tried varied and new inventions with divers tints and dark colours, hoping to win a place among the first masters. But Michelagnolo, firmly founded in the profundity of his art, has shown to all who know the true road to perfection.

To return to the scene. Michelagnolo had already finished three-quarters of his work when the

Opposite: The Last Judgment, 1536-41

Pope went to see it. M. Biagio of Cesena, master of the ceremonies and a scrupulous man, who accompanied him, when asked his opinion, said it was a disgrace to have put so many nudes in such a place, and that the work was better suited to a bathing-place or an inn than a chapel. This angered Michelagnolo, and in revenge, as soon as they had gone, he drew M. Biagio, without his model, as Minos in Hell among a troop of devils, with a great serpent wound about his legs. It was in vain that M. Biagio besought the Pope to make Michelagnolo remove it, and there it still is. About this time Michelagnolo fell a short distance from the scaffold and injured a leg. In his pain and anger he refused to be attended. But Maestro Baccio Rontini, a Florentine, his friend and a clever physician, who loved the arts, took compassion on him, and went to his house. When no one answered his knock, he entered by a secret way, and passing from room to room found Michelagnolo in desperate case. Baccio refused to leave him before he was healed, when he returned to his work, and by continued application

Opposite: Study of a flying angel for the Last Judgment,
c. 1534-6. For verso see p. 142

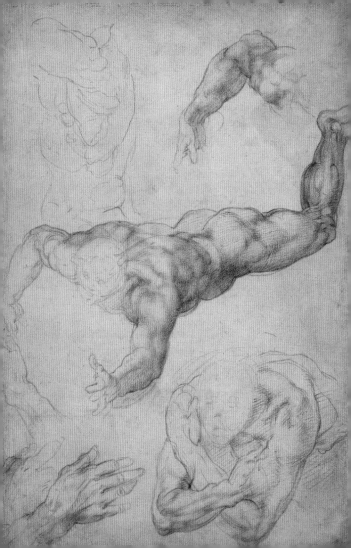

finished it in a few months, realizing the saying of
Dante—

*Morti li morti, i vivi parean vivi**

showing the misery of the damned and the joy of
the blessed. In this Judgment he not only far sur-
passed the other great masters who had worked
there, but his own celebrated work in the vaulting.
He has imagined the terror of those days, represent-
ing too the sorrow of those who have not lived well,
the Passion of Christ, with nude figures in the air
bearing the cross, the column, the lance, the sponge,
the nails, and the crown, in varied attitudes, with an
easy mastery of the difficulties. Christ is seated, and
turns with a terrible expression towards the damned,
to curse them, while the Virgin in great fear shrinks
into her mantle and hears and sees the ruin. A quan-
tity of figures form a circle, prophets, apostles, and
notably Adam and St Peter, one as the origin of men
come to judgment, and the other as the foundation
of the Christian religion. At their feet is a fine St

* The dead seem dead, the living alive

*Opposite: Study of angels for the top right lunette (see p. 23) of the Last
Judgment, c. 1534-36 . Verso of sheet illustrated p. 141*

Bartholomew showing his flayed skin. There is also a nude St Laurence, besides countless saints and other figures embracing and rejoicing at attaining eternal happiness by the grace of God as a reward for their actions. At the feet of Christ are the seven angels described by St John, with the seven trumpets, the sound of which makes the hair rise, so terrible are they to see. There are two angels, each holding the Book of Life, and hard by are the Seven Mortal Sins in the shape of devils dragging souls to Hell, in fine attitudes and admirably foreshortened. In the Resurrection, Michelagnolo has shown how the dead receive their bones and flesh and fly to heaven like the living, some of the blessed aiding them, together with many other ideas appropriate to such a work, studied and worked at by him. Thus in the barque of Charon we see him fiercely beating with his oar the souls thrust into it by the devils, as in the well-known words of Dante—

> *Caron demonio con occhi di braga*
> *Loro accennando, tutte le raccoglie:*
> *Batte col remo qualunque si adagia.* *

* Charon, demoniac form/ With eyes of burning coal, collects them all / Beck'ning, and each, that lingers, with his oar/ Strikes.

It is impossible to describe the variety in the heads of the devils. The sinners display their sin and fear of damnation. The whole work is finely and harmoniously executed, so that it looks as if it had been done in one day, and no illuminator could have equalled its execution. Indeed the number of figures and the force and grandeur of the painting are such that it is impossible to describe it. Every human emotion is represented and marvellously expressed. The proud, envious, avaricious, luxurious, and others may be recognized by an intelligent observer from their attitudes and treatment. It is marvellous that this great man, who was always wise and prudent, and had met many people, should have acquired a practical knowledge of the world such as is gained by philosophers by means of speculations and books. A man of judgment who understands painting will see the force of art in the thoughts and emotions of the figures, never displayed by any other artist. Thus we notice how he varied the attitudes in the diverse gestures of young and old, men and women, so that who can help seeing the grandeur of art joined to his natural grace?— for he

Overleaf: Sts Lawrence, Bartholomew, Catherine , Sebastian, and souls being taken down to torment, from the Last Judgment, 1534-41

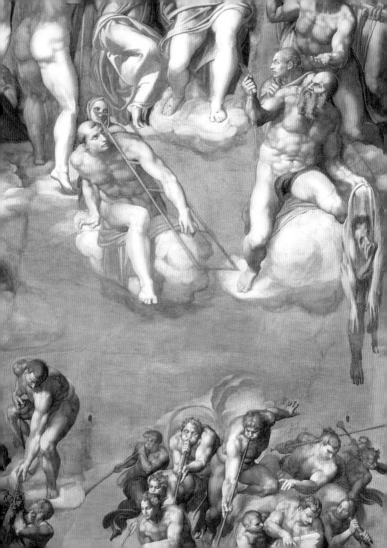

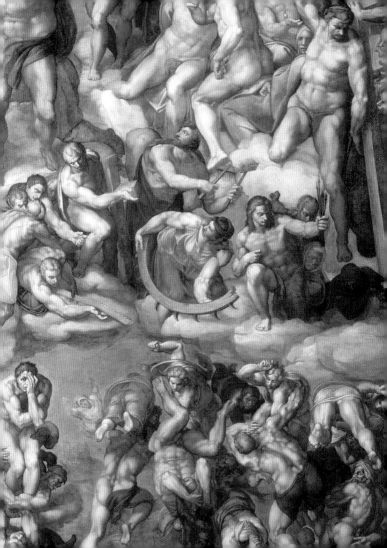

has laid bare all hearts. Here are foreshortenings which seem in relief, done with softness and delicacy, while his treatment of the parts show what paintings may be when executed by good and true masters. The outlines are such as no other could have done, and display an actual judgment, damnation, and resurrection. This great painting is sent by God to men as an example to show what can be done when supreme intellects descend upon the earth, infused with grace and divine knowledge. It takes captive those who think they know art, who tremble at the genius of the master in seeing his handiwork, while in regarding his labours their senses are overcome by thinking how other pictures can possibly bear comparison with them. Happy indeed is he who has seen this stupendous marvel of our century. Most happy and fortunate was Paul III, in that God consented to confer this memorial, this boast of writers under his rule. How much are his merits enhanced by the artist's skill. Artists born in this century owe Michelagnolo a great debt, for he has removed the veil from all imaginable difficulties in his painting, sculpture, and architecture. Michelagnolo laboured upon this work for eight years and uncovered it in 1541, I think on Christmas Day, to the marvel of all Rome and the whole world. I was

at Venice, and when I went to Rome to see it I was thunderstruck.

Pope Paul had caused a chapel called la Paolina to be built by Antonio da Sangallo on the same floor, in imitation of that of Nicholas V. He wished Michelagnolo to do two large square paintings. In one the artist did a Conversion of St Paul with Christ in the air and a multitude of naked angels with beautiful movements, and Paul in fear and amazement on the ground, surrounded by his horse and the soldiers engaged in lifting him, while others flee in varied and beautiful attitudes, terrified at the voice and glory of Christ, and a fleeing horse drags along the man who is seeking to retain it, the whole scene being executed with extraordinary art and design. The other is a Crucifixion of St Peter, who is represented naked on the Cross, a remarkable figure. The executioners having made a hole in the ground are about to put the Cross in it, so that Peter shall be head downwards. Michelagnolo, as is mentioned elsewhere, only devoted himself to perfection in art, for we have here no trees, buildings, landscapes, or any variations or charms of art, because he never cared for such things, not wishing, perhaps, to lower his great mind to them. These were his last paintings, executed at the age of seventy-five. He has told me that they cost him great

labour, as painting, especially fresco, is not the work of an old man. He arranged that Perino del Vaga should decorate the vaulting with stucco and painting, and this was in conformity with the wish of Paul III. But the work was delayed, nothing more being done, as many things are left unfinished either owing to the fault of irresolute artists or of the neglect of the princes in urging them on.

Pope Paul had begun to fortify Borgo, and had taken thither Antonio da Sangallo and several lords to discuss the matter. He wished Michelagnolo to assist, knowing that the fortifications of S. Miniato at Florence had been designed by him. After many discussions, his opinion was asked. He being opposed to the advice of Sangallo and the others, said so frankly, to which Sangallo retorted that sculpture and painting were his arts, not fortification. Michelagnolo replied that he knew but little of sculpture and painting, but as he had thought much about fortifications and had experience, he thought he knew more than all the others there, and in the presence of the company he pointed out many of the errors committed by Antonio. The dispute waxed so hot that the Pope was obliged to impose

Opposite: Lamentation, c. 1530-35

silence, but before long Michelagnolo brought
designs for all the fortifications of the Borgo, which
prepared the way for all that was done afterwards,
and led to the abandonment of the S. Spirito Gate
nearly completed by Sangallo.

Michelagnolo's spirit could not rest idle, and as
he was unable to paint he took a piece of marble to
make four figures larger than life-size, of a Dead
Christ, as a pastime, and because he said the use of
the mallet kept him in health. This Christ, taken
down from the cross, was supported by the Virgin
assisted by Nicodemus and one of the Maries, as the
Madonna, overcome by grief, does not possess the
strength. No better presentation of a dead body has
ever been made than the Christ with his lifeless limbs
in different postures, varying not only from others
but from the master's own work. It is a laborious
work and truly divine, but it was left unfinished, as I
shall relate, and it suffered many misfortunes
although Michelagnolo intended it for his own tomb
at the foot of the altar, where he hoped to be laid.*

In 1546 Antonio da Sangallo died, leaving the
direction of the fabric of St Peter's vacant, and var-
ious opinions as to his successor obtained among the

* Museo dell'Opera del Duomo, Florence. See illustration p. 181

deputies about the Pope. At length the Pope, inspired I believe by God, decided to send for Michelagnolo. But the master refused the post, to escape such a burden, saying that architecture was not his art. But his prayers availed nothing, and the Pope ultimately commanded him to accept it. Much against his will, therefore, he, was obliged to take it up. So one day he went to St Peter's to see Sangallo's wooden model and examine the structure. He found there all the faction of Sangallo, who, putting the best face on the matter, came forward and said how glad they were that the work had been given to Michelagnolo, and that the model was a meadow that would afford inexhaustible pasture. 'You speak truly,' said Michelagnolo, meaning, as he afterwards told a friend, that they were like cattle in their knowledge of art. He used to say publicly that Sangallo had made the building without sufficient light, that he had used too many ranges of columns on the exterior one above the other, and that he approached nearer the German style, with his projections and angles, than to the good antique or modern manner. He might besides have saved fifty years in finishing it and more than 30,000 scudi of the cost, executing it with greater majesty, design, beauty, and convenience. Michelagnolo afterwards

made a model to bring the work to its present form, proving that he spoke the truth. This model cost him twenty-five scudi and was completed in fifteen days.* That of Sangallo is said to have exceeded 4,000, and occupied many years to make. From this we see that he was working for gain, and prolonged the work from year to year not intending to finish it, while Michelagnolo determined to carry it through. Such methods did not please him, and while the Pope was forcing him to take the office of architect, he said one day openly that he did not want to have anything to do with those who had intrigued with their friends to prevent him from having the work, and if he was to have charge of it he would not employ one of them. These words spoken in public excited much animosity against him as may readily be believed, which increased daily when they saw him change all the dispositions both inside and out, so that they were always seeking fresh means of annoying him. At length Pope Paul gave him absolute powers over the building to do and undo at will and to direct other ministers. Michelagnolo seeing the confidence which the Pope placed in him, desired that the deed should contain that he worked for the

* Lost

love of God in this task, without any reward, although the Pope had at first given him the ferry of the river at Parma, worth 600 scudi. He lost this by the death of Duke Pier Luigi Farnese, and received in exchange a Chancery of Rimini of less value. This did not affect him, and although the Pope frequently sent him money for such provision he always refused it, as M. Alessandro Ruffini, then the Pope's chamberlain, and M. Pier Giovanni Aliotti, bishop of Forlì, testify.

At length Michelagnolo's model was approved by the Pope. It made St Peter's smaller but much grander, to the satisfaction of all men of judgment, although many who think themselves connoisseurs do not approve of his dispositions. He found that the four principal pilasters made by Bramante, and left unaltered by Antonio da Sangallo, which bear the weight of the principal tribune, were feeble. He partly filled them up, making two spiral staircases beside them mounting to the top, with easy steps for the carriage of materials by mules, and enabling a man on horseback to ride to the level of the top of the arches. He made the first cornice above the arches of travertine, of circular form and with marvellous grace, impossible to improve upon, and very different from the others. He began the two large

niches of the crossing, and where eight tabernacles had been made towards the Campo Santo by Bramante, Baldassarre, and Raphael, continued by Sangallo, Michelagnolo reduced the number to three, forming three chapels vaulted with travertine and containing windows of striking grandeur. As these designs of Michelagnolo and Sangallo have been printed and published I do not think it necessary to describe them, except that Michelagnolo used every diligence in the places where changes had to be made to see that they were rendered strong, so that they should not be altered subsequently by others, a wise and prudent provision, for it is not sufficient to do well if the work is not assured against the presumption of the ignorant; and if one trusts more to words than deeds, and to the favours of the unwise, great disasters may supervene.

The Roman people, favoured by the Pope, desired to give a beautiful, useful, and convenient form to the Capitol, making steps and winding staircases adorned with antique statues, and they asked Michelagnolo's advice. He prepared a rich and beautiful design, making a façade of travertine on the east side where the Senate House stands, with steps rising to a terrace, on two sides, by which one approaches the middle of the hall of the palace,

furnished with rich balusters serving as a parapet. To decorate the front he placed two ancient recumbent marble rivers on pedestals, the Tiber and the Nile, each of nine braccia, and in a large niche in the middle of the way he set up a Jupiter. On the south side, where the palace of the Conservatori stands, he made a rich façade, to render the building square, with a loggia full of columns and niches, containing numerous ancient statues and various ornaments about the doors and windows. Opposite, on the north side, he made a similar one, below Aracoeli, and steps in front on the west, with a terrace and parapet of balusters at the principal entrance, adorned by a row of pedestals containing all the noble statues with which the Capitol is now enriched. On an oval pedestal in the middle of the piazza stands a bronze equestrian statue of Marcus Aurelius, which Pope Paul had removed from the piazza of the Lateran where Pope Sixtus had placed it. It is so fine here that it is worthy of a place among the notable works of Michelagnolo, and its completion is now in the hands of M. Tommaso de' Cavalieri, a Roman noble, and one of the best friends Michelagnolo ever had, as I shall relate.

Pope Paul had got Sangallo to advance the Farnese palace, and as it needed a cornice for the

top he asked Michelagnolo to design one. Unable to refuse the Pope who loaded him with so many favours, he made a wooden model of six braccia of the proper size, and had it placed *in situ* on the palace to show the effect. It pleased the Pope and all Rome, and being executed it proved the finest and most varied cornice ever seen in ancient or modern times. After Sangallo's death the Pope wished Michelagnolo to have charge of the building, and he made the marble windows with beautiful columns of variegated marble above the principal door, and a large escutcheon of Paul III, founder of the palace, also of marble. He continued on the first floor of the court and the other two stories, decorating them with beautiful ornaments and graceful windows, adding an incomparable cornice, thus forming the finest court in Europe by his genius. He enlarged the great hall, and arranged the reception room before it, making the vaulting in a new form of a half oval. At that time an ancient Hercules was found in the Antonine baths, holding the bull by the horns with another figure helping him, surrounded by numerous shepherds, nymphs, and various animals, a work

Opposite: Study for a window at the Farnese Palace, 1547-49, reworked by Michelangelo in the early 1560's

of extraordinary beauty, the figures being perfect, made from one block without pieces. It was thought it would do for a fountain, and Michelagnolo advised that it should be taken into the second court and restored for that purpose. This advice gave general satisfaction, and the Farnese have lately had it carefully restored with this idea. Michelagnolo then directed the construction of a bridge over the Tiber to another palace and garden of the Farnese, so that from the principal door of the Campo di Fiore one looked straight through the court, fountain, Strada Giulia, the bridge and the other beautiful garden, right to the other door into the Strada di Trastevere, a rare thing worthy of the Pope, and of the genius, judgment, and design of Michelagnolo.

In 1547 Bastiano of Venice* died, and as the Pope wished to have the ancient statues of his palace restored, Michelagnolo recommended Guglielmo Della Porta, a Milanese sculptor, who had been introduced to him as a youth of promise by Fra Bastiano. For him Michelagnolo obtained the office of the Piombo and the task of restoring the statues. But Fra Guglielmo proved ungrateful, and afterwards joined Michelagnolo's opponents.

* Sebastiano, called 'del Piombo' from the papal office he enjoyed.

When Julius III succeeded Paul in 1549, the Cardinal Farnese directed Fra Guglielmo to construct a great tomb for the late pope, to be placed in St Peter's under the first arch of the new church under the tribune. As this blocked the plan of the church, Michelagnolo judiciously advised that it should not go there, and this aroused the hostility of the friar, who thought he acted from envy. But he afterwards recognized that the master was right, and that the fault rested with Guglielmo, who had the opportunity and did not finish it, as will be said elsewhere.

In 1550 I went to Rome to serve Julius III, being glad of such employment, which brought me near to Michelagnolo. He desired that the tomb should be in one of the niches where the column of the possessed now is, and which is its proper place, and I was employed to induce Pope Julius to select the other niche for his own tomb. But the opposition of the friar prevented his tomb from being finished, and the other was never made, just as Michelagnolo had predicted.

In this year Pope Julius began a marble chapel in S. Pietro in Montorio, with two tombs for Cardinal Antonio de' Monti, his uncle, and M. Fabiano, his grandfather, the founder of that illustrious house. Vasari having made designs and models for these,

the Pope wished Michelagnolo to value them, Vasari beseeching the Pope to let Michelagnolo have the protection of them. Vasari proposed Simon Mosca for the carving and Raffaello Montelupo for the figures; but Michelagnolo advised him not to have carving of foliage, saying that with marble figures it was best to have nothing else. Vasari feared that the work would look poor, but when it was finished he admitted the master's good judgment. Michelagnolo did not want Montelupo to have the figures because he had done so badly in the tomb of Julius II, and he agreed the more readily to Vasari's recommendation of Bartolommeo Ammannati, although he had a personal dislike for him and for Nanni di Baccio Bigio. It arose from a small matter, for when boys they had taken away many of Michelagnolo's designs from his pupil, Antonio Mini, moved more by love of art than mischief. These were all returned by the magistracy of the Eight, and at the intercession of his friend, M. Giovanni Norchiati, canon of S. Lorenzo, to save them from further punishment. Vasari, in speaking of this with Michelagnolo, laughingly said that he did not think they deserved any blame, and in their place he would have taken not drawings only, but everything he could lay hands on, simply to learn art. He added that those who

aspire to talent should be encouraged and rewarded, and not be treated like those who steal money and goods; and so he turned the matter into a jest. The work was begun, and that same year Vasari and Ammannati went to Carrara from Rome for the marble.

At that time Vasari spent every day with Michelagnolo, and one morning in the holy year for visiting the seven churches, the Pope granting them double indulgence. Between the churches they had many useful discussions on arts and crafts, and Vasari wrote down the whole dialogue, which he will publish at a fitting opportunity, with other matters relating to the arts. That year Pope Julius confirmed the powers of Michelagnolo over St Peter's, and though the faction of Sangallo spoke against it, the Pope would hear nothing, for Vasari had shown him that Michelagnolo had given life to the building, and he succeeded in persuading the Pope to do nothing concerning the design without consulting the master. Thus he took Michelagnolo's advice about the Villa Giulia and the Belvedere, where he constructed a new flight in place of the semi-circular staircase of eight steps, and then eight more turned inwards already constructed by Bramante. This was erected in the great recess in the middle of Belvedere.

Michelagnolo also designed the square staircase with the balustrade of peperino marble of great beauty, now standing.

That year Vasari had finished printing his *Lives of the painters, sculptors, and architects* in Florence without writing the life of any one then living, although some were old, except Michelagnolo, to whom he presented the work. The master accepted it gladly. Vasari had received much information from him, as being the oldest and most judicious artist, and after reading it Michelagnolo sent him the following sonnet written by himself, which I rejoice to put here in memory of his friendship.

Se con lo stile e co' colori avete
 Alla natura pareggiato l'arte
 Anzi a quella scemato il pregio in parte,
Che'l bel di lei piu bello a noi rendete
Poiche con dotta man posto vi sete
 A piu degno lavoro, a vergar carte,
 Quel chevi manca, a lei di pregio in parte,
Nel dar vita ad altrui, tutto togliete.
Che se secolo alcuno omai contese
 In far bell' opre, almen cedale, poi
 Che convien ch'al prescritto fine arrive.
Or le memorie altrui, gia spente accese

Tornando, fate or che fien quelle e voi,
Malgrado d'essa, eternalmente vive. *

Vasari departed for Florence, leaving the care of Montorio to Michelagnolo. M. Bindo Altoviti, then consul of the Florentine nation, was a great friend of Vasari, and told him that it would have been better to have had the tomb erected in the Florentine church of S. Giovanni, and that he had spoken of it to Michelagnolo, who agreed, and would see the work done. This pleased M. Bindo, and being very intimate with the Pope, he warmly advocated the placing of the tombs and chapel done for Montorio, in that church, adding that this would induce the Florentines to spend money on the church and finish it. If the Pope made the principal door, the merchants would do six, and the remainder would be taken up one by one. The Pope therefore changed

* If with the pen and colours you have made Art equal Nature, you have now surpassed her, rendering her beauties even more beautiful. Now you have set yourself a worthier task, and by supplying the only thing left wanting in giving life to others, you have robbed her of all. Is there an age whose labours may not have reached the zenith, yet through you it reaches its appointed goal. These memories of others, revived by you, will endure for ever with you, in spite of themselves.

his mind, and though the model had been made and the price fixed, he went to Montorio and sent for Michelagnolo, to whom Vasari wrote daily, and who replied, relating his doings. On August 1, 1550, Michelagnolo wrote to him of the Pope's change of plan. These are his very words:—

MY DEAR M. GIORGIO,

I have written nothing to you about the Pope giving up the rebuilding of S. Pietro in Montorio, as I know you are informed by your man. Now I will tell you what followed. Yesterday morning the Pope went to Montorio and sent for me. I met him on the bridge as he was returning, and had a long discussion with him about the tombs, and finally he said he had decided not to have the tombs there, but in the Florentine church, and asked me for my opinion and designs. I encouraged him in his purpose, thinking that this might lead to the finishing of the church. With regard to your last three letters, my pen is unequal to attaining such heights, but if I only had a part of the qualities you ascribe I should rejoice, because then you would have in me a servant good for something. But as you are the raiser of the dead, I am not surprised that you should add life to the

living, or the bad living long due to die. To conclude, I am ever yours,

MICHELAGNOLO BUONARROTI, at Rome.

Meanwhile, the nation was looking for money, and difficulties arose, so that nothing was concluded, and the matter lapsed. Vasari and Ammannati, having obtained all the marble at Carrara, sent a great part to Rome with Ammannati, who took a letter from Vasari to Michelagnolo to ask the Pope where the tomb was to be, so that he might begin it. Michelagnolo immediately spoke to the Pope, and wrote back:—

MY DEAR M. GIORGIO,

Immediately Bartolommeo arrived here I went to speak to the Pope, and seeing that he wanted to have the tombs at Montorio, I looked out a mason from St Peter's. Tantecose heard of it, and wanted to send another after his own mind, but I withdrew, not desiring a contest with the weathercock or to meddle with the business. However, it seems that the Florentine church is no longer in question. Return soon, and fare you well. I can think of no more.

Oct. 13, 1550.

Michelagnolo called Monsignor of Forlì 'Tantecose', because he wanted to do everything, for he was master of the Pope's chamber, head of the medals, cameos, bronze figurettes, paintings and designs, and he desired to have the control of everything. Michelagnolo avoided him because he was always thwarting him, and the master feared trouble if he had anything to do with him. Thus the Florentine nation lost a fine opportunity, to my great sorrow, and God knows if it will occur again. I have mentioned the story because it shows how Michelagnolo was always ready to help his friends, his country, and the arts.

Vasari had no sooner reached Rome, before the beginning of 1551, when the Sangallo faction made a conspiracy against Michelagnolo, to induce the Pope to summon all the builders in St Peter's, to show him by false calumnies that Michelagnolo had spoiled the structure. He had already made the king's recess, where the three chapels are, with the three windows above, and not knowing what was to be done in the vaulting, they had ignorantly informed Cardinal Salviati the elder and Marcello Cervini, afterwards Pope, that St Peter's was badly lighted. When all were assembled the Pope told Michelagnolo that the recess was badly lighted. He

answered: 'I should like to hear these deputies speak.' Cardinal Marcello replied: 'We are they.' Michelagnolo said: 'Monsignor, three more windows of travertine are to go to the vaulting.' 'You never told us that,' said the cardinal. 'I am not obliged to tell you or anybody else what I propose to do,' retorted the artist. 'Your office is to collect the money, and protect it from thieves; you must leave the design and charge of the building to me.' Turning to the Pope, he said: 'Holy Father, you see what profit I have; for if these labours do not benefit my soul, I am losing my time and trouble.' The Pope, who loved him, laid his hands on his shoulders, and said : 'Do not doubt that you will gain both in soul and body.' The Pope's love for him was thus greatly increased by removing this obstacle, and he commanded that he and Vasari should be at the Villa Giulia on the following day. Then they had long discussions on the work, nothing being done or proposed without consulting Michelagnolo. Michelagnolo went there frequently with Vasari, and on one occasion, when the Pope was standing by the fountain of Acqua Vergine with twelve cardinals, Michelagnolo arrived. The Pope, who always paid the highest honours to his genius, wished the master to sit beside him, but Michelagnolo humbly refused.

He did a model for the façade of the palace which the Pope wished to build next to S. Rocco, proposing to use the mausoleum of Augustus for the rest of the building. This would be hidden by the façade, which is most varied, ornate, and original, restricted by no laws of architecture, ancient or modern, for Michelagnolo possessed a most original genius. The model is now in the possession of Duke Cosimo, who had it from Pius IV when he went to Rome, and he holds it to be one of his choicest treasures. The Pope thought so much of Michelagnolo that he always sided with him against the cardinals and others who tried to calumniate him, and he wished all artists, however excellent, to go to his house. The Pope had such respect for him, that in order not to annoy him he did not ask him to do many things which he might have attempted, old as he was.

Under Paul III Michelagnolo had begun to rebuild the Ponte S. Maria at Rome, damaged and weakened by the current and its age. He made the foundations with coffer-dams, and diligently repaired the piles, finishing a great part, and incurred great expenses on wood and travertine. In a congregation of the clerks of the chamber under Julius III it was proposed to give it to Nanni di Baccio Bigio to finish in a short time at a small cost,

pretending to relieve Michelagnolo, who neglected it, they said, and who would never get it done. The Pope, who disliked quarrels, innocently gave power to those clerks who had charge of it as their affair. They gave it to Nanni with a free hand, without Michelagnolo knowing of it. Nanni, not under-standing the necessary precautions, removed a great quantity of travertine with which the bridge had been annually strengthened and paved, and which rendered it stronger and safer, and put cement in its place, with buttresses outside, so that it seemed com-pletely restored. But it was so weakened that it was destroyed five years after in the flood of 1557, showing the ignorance of the clerks of the chamber and the damage suffered by Rome in neglecting the advice of Michelagnolo, who frequently predicted this accident to his friends. I remember, when we were crossing it on horseback, he said, 'Giorgio, this bridge shakes, be careful lest it fall while we are on it.'

But to return to a former question. When the work at Montorio was finished to my great delight, I returned to Florence to serve Duke Cosimo in 1544. My departure grieved Michelagnolo and myself, for every day his enemies annoyed him first in one way and then in another. We wrote to each other every

day, and in April that year when Vasari heard that Michelagnolo's nephew Lionardo had a son and had acted as his godfather, he wrote to him, receiving the following reply:—

MY DEAR M. GIORGIO,

Your letter afforded me great pleasure seeing that you remember the poor old man, and also for your congratulations on the birth of another Buonarroto, for which I thank you. But I do not like so much ceremony, for no man ought to laugh while all the world weeps, and I do not think Lionardo should have celebrated a birth with as much joy as befits the death of one who has lived well. Do not wonder that I did not answer at once, I did not wish to appear mercenary. But if I deserved a tithe of your praises I should think myself to have partly repaid one to whom I am a debtor, for I owe you much more than I can ever repay, being old, though I hope to balance the account in the other life. Yet I ask your patience and remain yours. Matters are just as they were.

In the time of Paul III Duke Cosimo had sent Tribolo to Rome to see if he could persuade

Michelagnolo to return to Florence to finish the sacristy of S. Lorenzo. But Michelagnolo excused himself, saying that he was too old to support the fatigue, and giving many other reasons why he could not leave Rome. Tribolo then asked about the stairs of the library of S. Lorenzo, for which Michelagnolo had prepared many stones, as he was not certain of their form or substance. But Michelagnolo would only reply that he did not remember, in spite of Tribolo's prayers, who used the duke's name. The duke then induced Vasari to write and ask Michelagnolo what finish should be given to these stairs, hoping that his friendship would lead him to say something. Vasari wrote saying that he would alone carry out as faithfully as he could any instructions given. Michelagnolo then sent a description of the arrangement of the steps dated September 28, 1555.

MY DEAR M. GIORGIO,

With regard to the library stairs of which they have said so much to me, rest assured that I would not have needed so much solicitation if I had remembered my dispositions. I have turned over in my mind, as in a dream, a staircase, but I do not think it is exactly the one I thought of

then because it is clumsy. However I give it here. Take a quantity of oval boxes each about one palm deep, but not of equal length and breadth, and lay the first on the pavement at a distance from the door wall according as you want the stairs easy or steep. Put another upon it so that it becomes smaller in every direction, leaving room for the foot to rest, thus diminishing each step as it retires towards the door, the last step being of the same width as the door. The oval part of the step should have a wing on either side. The steps of the wings should rise similarly, but should not be oval. The middle flight shall serve for the Signori, and the ends of the wings must be towards the wall. From the middle downwards to the pavement the staircase must be about three palms from the wall, so that the basement of the vestibule shall not be occupied, and every front shall be free. I am writing nonsense, but I know you will find something suitable for your purpose.

Michelagnolo also wrote at that time that on the death of Julius and the succession of Marcellus who supported the faction opposed to him, that faction had begun once more to annoy him. Hearing this, the duke made Giorgio write telling him to leave

Rome and come to Florence, when the duke would only ask him to give advice and design his buildings, that the duke would give him everything he wished without his doing any work with his own hands. M. Lionardo Marinozzi also, the duke's chamberlain, took letters from his master and Vasari. But when Paul IV succeeded Marcellus, Michelagnolo went to kiss the Pope's foot, and as he received considerable offers and was anxious to finish St Peter's, he decided to remain. He excused himself to the duke, and wrote as follows to Vasari:—

MY DEAR M. GIORGIO,

I call God to witness that it was against my will that I was forced by Pope Paul III, ten years ago, to take up the building of St Peter's. If the work had been carried on until now as it was then I should be near the end and could rest, but it has been much delayed for lack of money, and to abandon it now that we have come to the most difficult part would be shameful, and I should lose the fruit of the labours of the last ten years which I have endured for the love of God. I write this in answer to yours, and I have a letter of the duke that makes me marvel that his Highness has deigned to write so kindly. I thank God and the

duke as much as I am able. I am wandering, for I have lost my memory and my wits, and writing is a great trouble to me because it is not my vocation. The conclusion is to say that I cannot abandon the building to a lot of rascals who would ruin it, and perhaps bring it altogether to a standstill.

Michelagnolo also wrote, saying that he had a house and many conveniences in Rome, worth thousands of scudi, and he suffered from pains in the kidneys and sides like all old men, as his physician Master Eraldo would testify, and that he had not the spirit for anything but death. He asked Vasari, as in many other letters, to beg the duke to pardon him, and, as I have said, he wrote to the duke, excusing himself, saying that if he had been able to travel he would have gone to Florence at once. Had he done so, I think he would never have returned, owing to the affection the duke bore him. Meanwhile he pressed on with his building to establish it so that it should never be changed. At this time he was told that Paul IV proposed to alter his Last Judgment in the chapel because of the nudes there. He replied, 'Tell the Pope this is a small matter, but let him reform the world, pictures are quickly mended.' He

was removed from the office of the chancery at Rimini. He refused to speak of this to the Pope, whose cupbearer had taken it away, and who did not know of it, and when the Pope asked him to pay him a hundred scudi a month for St Peter's and send a month's salary to his house, he refused it.

That same year occurred the death of his servant Urbino, whom he had rather made a companion. He had come to live with Michelagnolo in Florence in 1530, after the siege, when his pupil Antonio Mini went to France, and had served his master for twenty-six years, in his old age and sickness sleeping in his clothes at night to guard him, so that Michelagnolo loved him dearly and made him a rich man. To Vasari's letter of condolence he replied:—

MY DEAR M. GIORGIO,

I find it hard to write, but I must answer your letter. You know that Urbino is dead, to my great loss and unspeakable grief, for he was a great favour from God to me. The favour is that where-as when living he kept me alive, in dying he has taught me not to fear death, but to desire it. I had him twenty-six years, and found him devoted and faithful. I made him rich, and hoped for his support in my age, but he has been taken away, and

I can only hope to see him again in Paradise. God by his happy death has given me a foretaste, for he was more grieved for leaving me a prey to the vexations of the world than at death itself; the greater part of me has gone with him, and nothing is left to me but infinite sorrow. I bid you farewell.

Michelagnolo was employed by Paul IV on the fortifications of Rome, the Pope, having instructed Salustio Peruzzi to do the great door of the Castle of S. Angelo, now half ruined. He was also employed in distributing the statues, and in seeing and correcting the models of the sculptors. At that time the French army approached Rome, and Michelagnolo feared for the city and himself. So he decided to depart with Antonio Franzese of Castel Durante, who had been left there by Urbino to serve him. Accordingly he fled to the mountains of Spoleto, where he visited certain hermitages. At this time Vasari wrote to him, sending him a little work which Carlo Lenzoni, a Florentine citizen, had left at his death to M. Cosimo Bartoli to have it printed and dedicated to Michelagnolo. The master sent the following reply:—

MY DEAR M. GIORGIO,

I have received the book of M. Cosimo, and write to thank you, and ask you to thank him for me. Today with considerable fatigue and great delight I have visited the hermits of the Spoleto mountains, so that less than half of me has returned to Rome, for true peace can only be found in the woods. I have no more to say, and hope you are well and happy. —Sept. 18, 1556.

Michelagnolo worked almost every day as a pastime on the stone already mentioned, with the four figures, but now broke it for this reason. It had many flaws, and was so hard that the chisel frequently struck sparks, and also because his judgment was so exacting that nothing he did, satisfied him. He finished few statues in his manhood, the completed ones having been done in his youth, such as the Bacchus, the Pietà, the David, the Christ of the Minerva. It would not be possible to make the slightest alterations in these without injury. The others of Dukes Giuliano and Lorenzo, Night, Dawn, Moses, with eleven statues in all, remain unfinished. As he used to say, he would have sent few or none away if he had had to please himself, for his art and judgment were so advanced that so soon as he had found

a small error in a figure he let it alone and took up another block, thinking he would not experience the same fortune. He often said that this was the reason why he produced so few statues and pictures. He gave the broken Pietà to Francesco Bandini. At this time Tiberio Calcagni, a Florentine sculptor, had become a great friend of Michelagnolo through Francesco Bandini and M. Donato Giannotti. One day in Michelagnolo's house where the Pietà was, he asked the master why he had broken it and ruined such marvellous work. He replied it was because of the importunity of his servant Urbino, who urged him to finish it every day, and in hurrying he had removed a piece of the Virgin's elbow; he had come to hate it, and had been much bothered by a vein, and losing patience he broke it and would have smashed it to atoms had not Antonio his servant asked for it. Tiberio then spoke to Bandino who desired something of his, and Bandino induced Tiberio to promise Antonio two hundred gold scudi, and begged Michelagnolo that if Tiberio would finish it for Bandino with the help of his models, the labour should not be wasted and Michelagnolo should be satisfied. Accordingly Michelagnolo gave

Opposite: The Florence Pietà, 1547-55

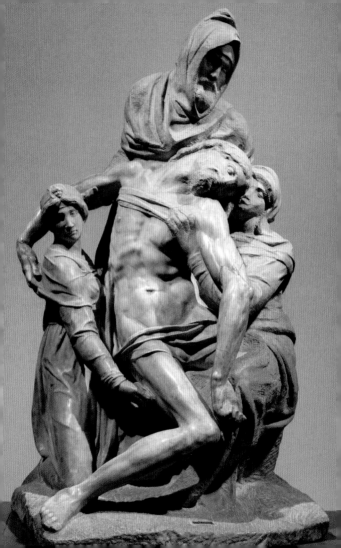

the pieces to them. They at once removed them, and Tiberio put some of the pieces together, but this work was stopped by the deaths of Bandino, Michelagnolo, and Tiberio. It is now in the hands of Pierantonio Bandino, Francesco's son, in his villa of Montecavallo.*

To return to Michelagnolo. Requiring some marble to pass his time in chiselling, he got another piece smaller than that of the Pietà of the same block. Pirro Ligorio, the architect, having entered the service of Paul IV and that of St Peter's, he began to harass Michelagnolo in the work of St Peter's, saying he was in his second childhood. The master in his anger would have returned to Florence, as Giorgio besought him to do in his letters. But he felt himself too old, being now eighty, and he wrote to Vasari sending him some spirited sonnets, saying he was at the end of his life and must fix his thoughts, being at the twenty-fourth hour, with every thought pointing to death. He wrote:—

God wills, Vasari, that I must travail another year or so, and I know you will call me old and foolish for making sonnets, but as many call me

*Museo dell'Opera del Duomo, Florence

dotard I mean to earn the title. I know your love, and should like my weak body to be laid beside my father's, as you suggest. But my death will be a great loss to St Peter's, because, as I have built my part so that it cannot be changed, I hope to live long enough to disappoint several intriguers who are awaiting my speedy decease.

With this letter he sent the following sonnet—

> Giunto è gia 'l corso della vita mia
> Con tempestuoso mar per fragil barca
> Al comun porto, or' a render si varca
> Conto e ragion d'ogni opra trista e pia.
> Onde l'affettuosa fantasia,
> Che l'arte mi fece idolo e monarca
> Conosco or ben quant'era d'error carca,
> E quel ch'a mal suo grado ogun desia.
> Gli amorosi pensier, gia vani e lieti,
> Che fien'or, s'a due morti mi avvicino
> D'una so certo, e l'altra mi minaccia.
> Nè pinger nè scolpir fra piu che queti
> L'anima volta a quello amor divino,
> Ch'aperse, a prender noi in croce le braccia.*

* The course of my life is now run, the frail bark has crossed the stormy sea to the common port, to render account of every work,

His thoughts were turned to God, and he left the care of the arts persecuted as he was by the evil-disposed artists, who wanted as he said to handle them. Vasari replied by order of Duke Cosimo, in a short letter, advising him to return, and with a sonnet of corresponding rhymes. Michelagnolo was willing to leave Rome, but he was too old and feeble, and his infirmity kept him there. In June 1557 he made a model of the vaulting for the recess of the King's chapel, to be made in travertine. But an error occurred because he could not go there so frequently as usual, as the foreman took the measure with only one centry when there should have been several. Michelagnolo sent the designs to his confidential friend Vasari, with these words at the foot of two—

The foreman took the centry coloured red for the whole vault, but when he reached the centre of the half-circle, he became aware of his error, as shown in black in the design. The vault has been

whether evil or good. Hence I see how great was my error in making art my idol and sovereign, and how evil is every man's thought. Where are my thoughts of love and joy when two-fold death draws nigh me, the one certain, the other menacing? Neither painting nor sculpture can afford peace to the soul which turns to that divine Love, which opens its arms to take us to the cross.

so advanced with this error that it will be neces-
sary to remove a large number of stones, for all is
travertine with no masonry of bricks, and the
diameter of the arch without the surrounding
cornice is twenty-two palms. This error has aris-
en because age has prevented me from going so
often as usual, although I had prepared an exact
model as I do of everything, and the vault which
I hoped would be done by now will not be fin-
ished this winter, and if shame and pain could
kill, I should not be living now. I beg you to
excuse me to the duke for not being in Florence.

On the ground plan he wrote:—

M. Giorgio, that you may better understand the
difficulty of the vaulting and its earth connection,
you must divide it into three parts corresponding
with the windows beneath, which are divided by
the piers, which rise pyramidically to the top of
the vault, in harmony with the bases and sides of
it. It was necessary to regulate them by countless
centrys, changing them frequently from point to
point without any general rule, and the circles
and squares approaching the middle of their
deepest part must diminish and increase on so
many sides and reach to so many points that the

true method is hard to find. However, with a model such as I make for everything, such an error as using a single centry for the whole should never have occurred, and this loss involved a shameful and expensive removal of many stones. The entire vaulting with sections and ornaments is of travertine like the posts below, an unusual thing in Rome.

These difficulties caused Duke Cosimo to relinquish his efforts to bring Michelagnolo to Florence, and he told the master that he was more anxious he should continue St Peter's than do anything else in the world, and that he should be free from worry. On the same sheet Michelagnolo wrote to Vasari thanking the duke for his kindness, saying: 'God be thanked, I can still serve Him with my poor body, though my memory and brain have gone to await it elsewhere.' The letter was dated August 1557, and Michelagnolo thus perceived that the duke esteemed his life and honour more than he himself. On all these matters and many others I have his own letters. Seeing little going on in St Peter's, and having well advanced the frieze inside the windows and of the double columns outside, which form a circle above the great round cornice to take the cupola,

Michelagnolo was encouraged by his best friends, the Cardinal di Carpi, M. Donato Giannotti, Francesco Bandini, Tommaso de' Cavalieri, and Lottino, to at least make a model of the cupola, as the vaulting was being delayed. He remained irresolute for several months and at last began one, slowly making a clay model before beginning a larger one in wood from his plans and elevations. He began the latter, which was finished in little more than a year by Maestro Giovanni Franzese, with great study and labour. It was of such size that the small details, including the ancient Roman palm were perfect, and it had finished parts, the columns, bases, capitals, doors, windows, cornices, projections, and every detail, so that no Christian country possesses a monument more grand or ornamental.*

If I have spent time in speaking of lesser things, I think it right to describe the design of the tribune as conceived by Michelagnolo, and I will write of it as shortly as possible, to preserve the work from the envy and malice of the presumptuous which harassed Michelagnolo in his life. My description may help the faithful executors to understand the master's intention and bridle the desire of the

* St. Peter's, illustrated overleaf

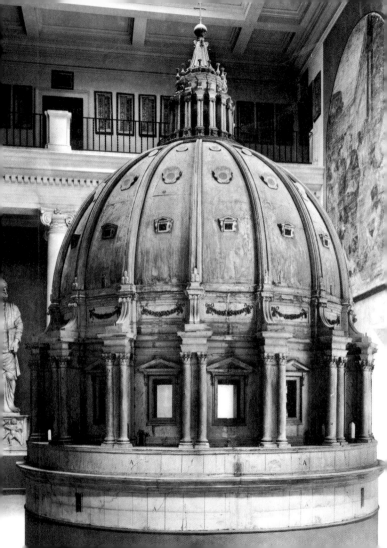

malignant to change it, while it will instruct and delight the choice spirits who love this art. The model provides for a span of 186 palms* from wall to wall across the great tribune over the great surrounding cornice, which rests on four large double pilasters with carved Corinthian capitals, decorated with architrave, frieze, and cornice, the whole in travertine. The cornice rests on the four large arches of the three niches, and the entrance forming the cross of the building. At the place where the cupola springs from the tribune is a basement of travertine with a way 6 palms broad, going round, 33 palms 11 inches thick, and 11 palms 10 inches high to the cornice. The cornice above is about 8 palms, and the projection 6½ palms. There are four entrances into the tribune above the arches of the niches, dividing the thickness of the basement into three parts. The inside one is 15 palms, the outside 11 palms, and the middle 7 palms 11 inches, making a thickness of 33 palms 11 inches. The middle space is empty and

* A Roman architect's palm was 8.8 Imperial inches or 223 mm long, and divided into twelve inches

Opposite: Wooden model of the dome of St Peter's by Michelangelo and assistants, 1558-61, and with later additions

serves as a passage, with a barrel vault going round. Each of the four entrances has eight doors with four steps, one to the level of the cornice of the first basement 6½ palms broad, the second to the inner cornice surrounding the tribune 8¾ palms broad, affording easy access to the building, and there are 201 palms between the entrances, which being four in number makes a circuit of 806 palms. There is a step from the basement level where the columns and pilasters rest, and which forms a frieze about the windows; this is 14 palms 1 inch high. About it on the outside is a short cornice only projecting 10 inches, the whole of travertine. In the thickness of the third part is a step at every fourth part, facing two ways, 4¼ palms broad. This leads to the level of the columns. From this point start eighteen huge travertine pilasters, each adorned with two columns, and between them are the spaces for the windows to light the tribune. These are turned towards the middle from which they are 36 palms, and 19½ from the front face. On the outside of each are two columns, the dado at the foot of them being 8¾ palms and 1½ palms high. The base is 5 palms 8 inches broad, [. . .] palms 11 inches high. The shaft is 43½ palms, the diameter being 5 palms 6 inches at the base, and at the top 4 palms 9 inches. The Corinthian capital is

$6\frac{1}{2}$ palms high and 9 palms at top. Three sides of the columns show, the fourth being against the wall with half a pilaster at the corner, and in the middle is a door in the arch, 5 palms broad, 13 palms 5 inches high. The space between this and the capital of the pilasters and columns is filled with masonry and joins the other two pilasters, which are similar. These form an ornament beside the eastern windows round the tribune, the lights of which are $12\frac{1}{2}$ palms broad by about 22 high. The exterior is decorated with varied architraves $2\frac{3}{4}$ palms broad, and on the outside they are decorated with pediments and arches. They narrow to the interior to admit more light, and are lower on the inside to light the frieze and cornice. Between each are two flat pilasters, corresponding in height to the columns outside, making thirty-six columns outside and thirty-six pilasters inside. Above the pilasters is the architrave, $4\frac{5}{8}$ palms high, and the frieze $4\frac{1}{2}$ and the cornice $4\frac{2}{3}$ projecting 5 palms. Above are balusters for a passage, and there are steps with thickness of the space of 15 palms with two branches and another flight to mount to the top of the columns, so that the staircase, without impeding the light of the windows, communicates with a newel staircase of the same breadth which rises to the point where the cupola begins. The order, distribution and ornament

are so varied, convenient and strong, durable and rich, providing an effectual support for the two vaults of the cupola, that they form the most marvellous and well-contrived structures to be seen by understanding eyes. Strength is assured by the joints of the stones, all of which are strong, and the water is ingeniously carried off by numerous secret channels, the whole being so perfect that all other buildings erected hitherto are as nothing by comparison, and it is a pity that those in charge did not work at it with all their might that the author might have seen his beautiful and striking work completed before his death. Michelagnolo carried the building to this point, and only the vaulting of the tribune remained. As we have his model, I will continue by describing the arrangements he left for this. He established three points forming a triangle, thus: A. B. The point C. is the lowest, and forms the C. beginning with which he determined the first circle of the Tribune, and the form, height and breadth of the vaulting, which he directed should be constructed entirely of well-baked bricks. This was 4½ palms thick both at top and bottom, leaving a space in the middle of 4½ palms at the foot which serves for the steps to the lantern, rising from the level of the cornice where the balusters are. The

section of the other part at the point designated B., $4\frac{1}{2}$ palms at the foot for the thickness of the vault, and the last section for the exterior, broad at the base and narrowing to the top, is at the point marked A., occupying all the middle space inside containing the steps, eight palms high, to admit of walking upright. The thickness of the vaulting gradually diminishes from $4\frac{1}{2}$ palms to $3\frac{1}{2}$ at the top, and the outside vault is united to the inside one with bands and steps so that one bears the other. Thus of eight divisions, four rest on the arches and the other four are tied upon the pilasters, to endure for ever. The steps between the vaults are made thus: They rise from the level where the vaulting begins in one of the four parts, each having two approaches crossing the steps in X shape, and leading to the middle of the section C. Having mounted half the section straight, the rest rises more gently, one curved, the other straight, until the eye is reached, where the lantern begins. About this begins a series of lesser doubled pilasters, corresponding with those below, and windows like those inside. Above the first great cornice inside the tribune he began the ribs of the vaulting, divided into sixteen ribs, as broad as the pilasters at the base and diminishing pyramidically to the eye of the lantern, resting at the foot on a pedestal of the same

breadth, twelve palms high, which rests on the plane of the cornice and encircles the tribune. The spaces between the ribs contain large ovals, each 29 palms high with rectangular apartments above, narrowing towards the top, 24 palms high. Above these is a circle of 14 palms forming in all a rich ground, for Michelagnolo designed the decoration of the ribs and these other parts to have cornices of travertine.

I must now mention the surface and decoration of the section of the vault where the roof is, which rises from a basement 25½ palms high, and rises from a socle which projects two palms, as do the mouldings at the top. He proposed to make the roof of lead as on old St Peter's, and made sixteen spaces, beginning at the point where the double columns end, with two windows between to light the middle space, thirty-two in all, and lighting the staircases between the vaults. To these he added corbels bearing a quarter circle, the whole forming a roof to throw off the rain. From the central point between the two columns the ribs sprung from where the cornice ends, being broad at the base and narrowing at the top, sixteen in all, and five palms broad. Between them was a square channel 1½ palms broad containing a staircase of steps about one palm high, mounting to the point where the lantern begins.

These are made of travertine and are protected
from the weather. Like the rest of the work he
designed the lantern to diminish towards the top,
concluding with a small temple of round columns in
pairs like those beneath, arranging the pilasters to
allow a passage about them, and to admit a view
through the windows into the tribune and the
church. He made the architrave, frieze and cornice
around it, projecting over the columns, above which
are spiral shafts and niches rising to the summit of
the coping and narrowing pyramidically at a third of
their height, towards the ball which bears the cross.
I might have entered into many details, such as pro-
vision for earthquakes, aqueducts, various lights and
other things, but as the work is unfinished I content
myself with having touched upon the principal parts
as best as I could. A brief sketch suffices, as the work
is in existence and may be seen, and this sketch
will suffice to enlighten those who have no knowl-
edge of it.

The completion of the model caused great sat-
isfaction not only to Michelagnolo's friends but to all
Rome. He continued to direct the work until the
death of Paul IV. The new pope, Pius IV, while leav-
ing Pirro Ligorio as architect of the palace, to finish
the little palace of the wood of Belvedere, made

advances to Michelagnolo and confirmed to him the powers over St Peter's granted by Paul III, Julius III, and Paul IV, restoring to him a part of the income taken away by Paul IV, and in his time the work of St Peter's progressed merrily. The Pope employed Michelagnolo to design a tomb for the Marquis of Marignano, his brother, allotted by the Pope to the knight Leone Leoni of Arezzo, an excellent sculptor and great friend of Michelagnolo, to be placed in the Duomo of Milan. At that time Leoni made a most lifelike medal of Michelagnolo,* and on the reverse, as a compliment to him, a blind man led by a dog, and the legend—

Docebo iniquos vias tuas, et impii ad te convertentur.†

Michelagnolo was greatly delighted, and gave him a wax model of Hercules crushing Antaeus, and some designs. There are no other portraits of Michelagnolo except two paintings, one by Bugiardino,‡ the

* Illustrated p. 253. Various examples survive, as does a preliminary model in wax, British Museum. † Then will I teach transgressors thy ways; and sinners shall be converted unto thee. (Psalm 51:13) ‡ Possibly the painting exhibited in the Casa Buonarroti

other by Jacopino del Conte,* a bronze relief by Daniello Ricciarelli† and this medal, copies of which I have seen at several places in and out of Italy. That same year Cardinal Giovanni de' Medici, Duke Cosimo's son, went to Rome to receive the red hat from Pius IV, and arranged for Vasari to go with him. Giorgio went gladly and remained about a month, enjoying the society of Michelagnolo, who was very fond of him and where he was constantly. By the duke's order Vasari brought with him the wooden model of the ducal palace at Florence, with the designs of the new apartments built and decorated by him, which Michelagnolo wished to see. Being old he could not visit the works, which were copious, diverse with varied fancies and inventions on the Sky, Saturn, Ops, Ceres, Jupiter, Juno, Hercules, one in every room, with their legends. The other rooms beneath these were called after the Medici, Cosimo the elder, Lorenzo, Leo X, Clement VII, Sig. Giovanni, Duke Alessandro, and Duke Cosimo, containing not only their deeds but the

*Unfinished, and now in the Metropolitan Museum of Art, New York. Another version is in the Casa Buonarroti. † Daniele da Volterra. A version of this relief is in the Ashmolean Museum, Oxford.

portraits of themselves and their children, the rulers, soldiers, and men of letters. Vasari has written a dialogue on those declaring the whole matter, which was read by Annibale Caro and greatly delighted Michelagnolo. It will be printed soon when I have more time. These things aroused Vasari's desire to undertake the great hall, as the ceiling was low and badly lighted. But the duke could not decide to raise it, not because he feared the expense, but owing to the danger of making the king-poles thirteen braccia higher. However he agreed with his usual judgment to consult Michelagnolo, who on seeing the numerous inventions became not a judge but a partisan, seeing that the work was easy and could be quickly executed. So on Vasari's return he wrote advising the duke to execute the work, which was worthy of his greatness.

That same year Duke Cosimo and the Duchess Leonora visited Rome, and immediately on their arrival Michelagnolo went to see them. The duke received him graciously, honouring his genius and making him sit beside him, where he spoke of all the duke's works and projects in painting and sculpture in Florence, and especially of the hall. Michelagnolo again advised the duke to go on with it, and expressed regret that he was not young enough to

serve him. The duke said he had found a method of working porphyry, and as Michelagnolo seemed incredulous, the duke sent him the head of Christ by Francesco del Tadda, which amazed him. Michelagnolo made several other visits during the duke's stay in Rome, and when the duke's son Don Francesco de' Medici visited him, he always addressed Michelagnolo with his cap in his hand, such was his reverence for him, and Michelagnolo wrote to Vasari saying he grieved he was old and ailing, as he would have liked to do something for that lad, and he tried to buy some beautiful antique to send him.

At that time the Pope asked Michelagnolo for a design for the Pia Gate. He made three of great beauty, and the Pope chose the least costly, and this was erected amid great admiration. Michelagnolo, seeing the Pope's humour, made several other designs of other gates of Rome, and asked the Pope to convert the baths of Diocletian into a Christian church as S. Maria degli Angeli, and made a handsome design which has since been carried out by many skilful architects for the Carthusian friars, to the admiration of the popes, prelates and courtiers, at his judgment in using the shell of the baths and forming a handsome church contrary to the opinion

of all architects, thus winning great praise and honour. For this place he designed a bronze ciborium for the sacrament, mostly cast by Jacopo Ciciliano, an excellent founder, capable of producing the most delicate work which is easily polished, and greatly pleasing Michelagnolo.

The Florentine nation had often proposed to begin the church of S. Giovanni in the Strada Giulia. Their wealthiest men met together, and had collected a good sum of money for the purpose. A discussion then arose among them, whether they should follow the old order or do something better, and they decided to build a new erection on the old foundations, appointing as overseers Francesco Bandini, Uberto Ubaldini and Tommaso de' Bardi. These requested Michelagnolo for a design, saying that it was a disgrace to the nation to have wasted so much money, without any profit, and if his genius could not finish it, they had no remedy. He promised gladly to oblige them at once, as in his old age he loved to work first for the honour of God, and next for his beloved country. In this discussion Michelagnolo had with him Tiberio Calcagni, a young Florentine sculptor, very anxious to learn art, who on going to Rome had taken up architecture. Michelagnolo was fond of him, and gave him his

broken marble Pietà to finish, and also a marble bust of Brutus larger than life, of which the head only was done.* He had copied this Brutus from one on a very ancient cornelian owned by Sig. Giuliano Cesarino, at the prayers of M. Donato Giannotti, his intimate friend, for Cardinal Ridolfi. As old age prevented Michelagnolo from drawing any more, he used Tiberio, whom he found modest and discreet, and directed him to prepare a plan for the site of the church. This was done, and although they did not think that Michelagnolo had yet done anything, he informed them through Tiberio that he had served them, and ultimately showed them five plans of beautiful churches which made the trustees marvel, and told them to choose one. They refused, preferring his judgment, but he insisted, and they unanimously selected one of the richest. Then Michelagnolo told them that neither the Romans nor the Greeks had ever possessed such a temple, unusual words for him as he was very modest. They finally decided that Michelagnolo should direct everything, and that Tiberio should bear the labour of executing the work, expecting he would serve them well. So they gave the plan to Tiberio, who

* Museo Nazionale del Bargello, Florence

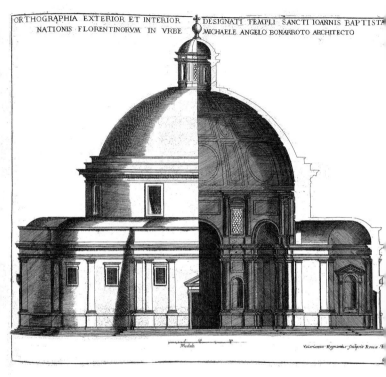

ORTHOGRAPHIA EXTERIOR ET INTERIOR DESIGNATI TEMPLI SANCTI IOANNIS BAPTISTA
NATIONIS FLORENTINORVM IN VRBE MICHAELE ANGELO BONARROTO ARCHITECTO

*Engraving after the lost model of Michelangelo's project for
S. Giovanni Fiorentino*

made a finished copy with sections and elevations, and showed the method of execution. In ten days Tiberio finished a clay model of ten palms, and as this pleased the nation, they had a wooden one made, now in their consulate*. It is the rarest church ever seen for its beauty, richness, and great variety. It was begun, and 5,000 scudi expended, but the assignments failing, it has most unfortunately been abandoned. Michelagnolo allotted to Tiberio a chapel in S. Maria Maggiore, begun for Cardinal S. Fiore, and left unfinished at the cardinal's death, and that of Michelagnolo, and Tiberio, whose early decease was a great loss.

Michelagnolo had spent seventeen years in the building of St Peter's, and the deputies had frequently desired to remove him. Not succeeding, they sought every means of opposing him, hoping to force him to resign, seeing that he was so old and unable to do much. Thus when Cesare da Castel Durante the overseer died, Michelagnolo sent Luigi Gaeta, a mere youth, but quite adequate, until he found a suitable man, in order that the building might not suffer. A section of the deputies had frequently attempted to appoint Nanni di Baccio Bigio,

* Lost, but known through engravings such as the one opposite.

who promised great things, and they dismissed Luigi in order to get the work into their hands. When Michelagnolo heard this, he wrathfully declared he would do no more to the building. Thus a report spread that he could do more, and that it would be necessary to appoint a substitute, because he had exclaimed that he would no longer be bothered with St Peter's. When this came to Michelagnolo's ears he sent Daniello Ricciarelli of Volterra to the Bishop Ferratino, one of the overseers, who had told the Cardinal of Carpi that Michelagnolo had told a servant that he would be bothered no more with the building. Daniello said this was not Michelagnolo's intention; but Ferratino replied that it was a pity that the master had not communicated his intentions, but that a substitute ought to be appointed, and he would willingly have accepted Daniello. He then informed the deputies in Michelagnolo's name that they had a substitute; however, Ferratino presented not Daniello but Nanni instead, who was accepted, and lost no time in erecting a scaffolding by the Pope's stables on the hill to ascend to the top of the great apse, facing that side, and bringing great beams of fir-wood, saying it was better so, as otherwise too much rope would be needed. When Michelagnolo heard this he at once went to the Pope

to the piazza of the Capitol, and speaking loudly he was brought into the chamber, where he said, 'Holy Father, the deputies have substituted for me a man whom I do not know, but as they and your Holiness feel I am no longer fit, I will return to Florence to rest, as the Grand Duke so much desires, and there end my days, and I therefore ask for my *congé*.' The Pope was hurt, and comforting him with fair words, told him to repair on the following day to Aracoeli, where he would assemble the deputies and hear what they said. They declared that the building was being spoiled and contained errors. The Pope knew this was not true, and ordered Sig. Gabrio Scierbellone to go with Nanni to the building and ask him to point them out. Sig. Gabrio thereupon perceived that Nanni's accusations proceeded merely from malignity, and so Nanni was ignominiously expelled in the presence of many lords, it being said that he had ruined the Ponte S. Maria, and that at Ancona, where he wished to clear the port at small cost, he had done more harm in one day than the sea had in ten years. That was the end of Nanni at St Peter's, and Michelagnolo devoted himself entirely to the church, having spent the eighteen years in strengthening it, for he feared that envy might cause it to be changed after his death, and it is now so strong that

it may be safely vaulted. So we see that God, who protects the good, defended him through his life, and has always favoured this building. Thus even during his life Paul IV ordained that nothing of his plans should be changed, and Pius V, his successor, did the like, appointing as executors Pirro Ligorio and Jacopo Vignola, but when Pirro presumptuously wished to alter something, he was immediately removed. The Pope, who was as zealous for the structure as for the Christian religion, when in 1565 Vasari went to kiss his feet, and again in 1566, would only allow the procurator to deal with the designs left by Michelagnolo. To obviate such disorders, the Pope commanded Vasari to go with M. Guglielmo Sangalletti, the Pope's secret treasurer, to Bishop Ferratino, head of the builders of St Peter's, directing him to observe all the directions and memoranda communicated by Vasari, so that no presumptuous man should move a jot of what the genius of Michelagnolo had devised. Vasari's great friend, M. Giovambatista Altoviti, was then present. Ferratino readily heard Vasari, and promised faithfully to observe everything, and also to protect the labours of the great Michelagnolo.

About a year before Michelagnolo's death, Vasari had secretly induced Duke Cosimo to get the

Pope, through M. Averardo Serristri, his ambassador, to take great care of Michelagnolo, as he was much broken, and if any accident happened, his property, designs, cartoons, models, and money should be inventoried and kept for the use of St Peter's, and for the sacristy and library of S. Lorenzo, if anything concerning them should be found, such that they should not be removed as usually happens. This plan succeeded. In the following Lent the master's nephew, Lionardo, desired to go to Rome, as though divining that Michelagnolo was near his end, and when Michelagnolo fell sick of a slow fever, he made Daniello send for Lionardo. But the malady growing worse, while M. Federigo Donati, his physician and others were about him, he made his will with perfect consciousness, leaving his soul to God, his body to the earth, and his property to his nearest relations, warning his friends in this passing life to remember the Passion of Christ, and so he passed to a better life at eleven at night on February 17, 1563, in the Florentine use, 1564 following the Roman.

Michelagnolo was devoted to the labours of the arts, seeing he mastered every difficulty, possessing a genius admirably adapted to the excellent studies of design. Being perfect in this, he often made dissections, examining the ligatures, muscles, nerves, veins,

and various movements, and all the postures of the human body, and even of animals, especially horses, which he loved to keep. He liked to examine the arrangement and method of everything, and no one could have treated them better even if they had studied nothing else. Thus in all his inimitable works, both with brush and chisel, he has displayed such art, grace, and vivacity, that I may say with due respect that he has surpassed the ancients, making difficulties appear easy, though they are found by those who copy them. Michelagnolo's genius obtained recognition in his life, and not, as in so many cases, after his death, as Julius II, Leo X, Clement VII, Paul III, Julius III, Paul IV, and Pius I, always required him by them, and so did Suleiman the Sultan, Charles V, the government of Venice, and Duke Cosimo, simply on account of his great talents. This only occurs to men of great genius like his, for all the arts were perfected in him in a manner God has vouchsafed to none other. His imagination was so perfect that he could not realize with his hands his great and sublime conceptions, and so he frequently abandoned his works and spoiled many, for I know that before his death he burned a great number of his designs, sketches, and cartoons, in order that no one should perceive his labours and

the efforts of his genius, that he might not appear less than perfect. I have found some of his drawings in Florence, and put them in my book, and though they show his greatness, yet we see that when he wished to create Minerva from the head of Jupiter he would have needed Vulcan's hammer. He used to make his figures of ten or twelve heads, endeavouring to realize a harmony and grace not found in nature, saying that it was necessary to have the compasses in the eye not in the hand, because while hands perform the eye judges. He observed the same method in architecture.

Let no one marvel that Michelagnolo loved solitude, for he was devoted to art, which demands man to itself; and because those who study must avoid society, the minds of those who study art are constantly pre-occupied, and those who consider this to be eccentricity are wrong, for he who would do well must avoid cares and vexations, since genius demands thought, solitude, and comfort, and a steadfast mind. Nevertheless he loved the friendship of many great and learned men at seasonable times, while Cardinal Ippolito de' Medici was much attached to him. Learning that a Turkish horse of his pleased Michelagnolo for its beauty, the cardinal sent it to him with ten mules laden with fodder, and

a servant to look after it, a gift the artist gladly accepted. Another friend was Cardinal Pole, whose ability and goodness Michelagnolo loved. Other friends were Cardinal Farnese and Cardinal S. Croce, afterwards Pope Marcellus, Cardinal Ridolfi, Cardinal Maffeo, Monsignor Bembo, Carpi, and many other prelates whom I need not mention, Monsignor Claudio Tolomei, M. Ottaviano de' Medici, his godfather, M. Bindo Altoviti, to whom he gave the cartoon of Noah's drunkenness in the chapel, M. Lorenzo Ridolfi, M. Annibal Caro, M. Giovan. Francesco Lottini of Volterra, and far more than all the rest, M. Tommaso de' Cavalieri, a Roman noble, a young man devoted to art, who learned to draw, and for whom he made stupendous designs in black and red chalk, including a Rape of Ganymede,* the Vulture eating the Heart of Tityus, the Fall of the Chariot of the Sun into the Po, and a Bacchanalia of Infants,† all most rare and unique. Michelagnolo drew a life-size portrait of M. Tommaso, his first and last, for he abhorred drawing

* The Ganymede is in Fogg Art Museum, Cambridge, Mass. † The Bacchanalia, Tityus and the Fall of the Chariot of the Sun (or Fall of Phaeton) are in the Royal Collection, Windsor. See illustration of study for the Fall of Phaeton on p. 14.

anything that was not of the utmost beauty.* These cartoons secured M. Tommaso a good success, such as Michelagnolo had already given to Fra Bastiano of Venice;† indeed, M. Tommaso has preserved these wonderful drawings as keepsakes, and courteously allows artists to use them. Michelagnolo always cultivated the friendship of noble, meritorious, and worthy men, showing his judgment and taste in all things. M. Tommaso afterwards induced Michelagnolo to do several designs for friends, such as the Annunciation for the Cardinal di Cesis, coloured by Marcello, a Mantuan, and placed in the marble chapel built by the cardinal in S. Maria della Pace at Rome.§ He also did another Annunciation, coloured by Marcello, for S. Giovanni Laterano, the design being in the hands of Duke Cosimo, who received it from Lionardo Buonarroti, the artist's nephew, and who values it highly.‡ The duke also owns a Christ in the Garden, and many other designs, sketches, and cartoons of Michelagnolo, with a statue of Victory over a prisoner, five braccia

* The portrait of Tommaso is lost, but Michelangelo did at least one portrait drawing that survives, of Andrea Quaratesi (c. 1528-32), British Museum, London. † Sebastiano del Piombo § Lost, but copies survive ‡ Lost

high, and four prisoners sketched,* illustrating a safe method of making marble figures without spoiling the blocks. The method is this. One takes a figure of wax or other firm material and immerses it in a vessel of water; the figure is then gradually raised, displaying first the uppermost parts, the rest being hidden, and as it rises more and more the whole comes into view. This is the way to carve figures, and it was observed by Michelagnolo in his prisoners, which the duke keeps to serve as a model for his academicians.

Michelagnolo loved the society of artists, and associated much with them, as with Jacopo Sansovino, Rosso, Pontormo, Daniello of Volterra, and Vasari, to whom he showed great affection, inducing him to study architecture, and intending to employ him, whom he often consulted, and with whom he discussed art. Those who say he would not teach are wrong, as he was always assisting friends and those who asked advice; but as I was often present, modesty commands my silence, for I will not disclose the faults of others. He had bad fortune with those who lived with him, for though Piero

* The Victory is in the Palazzo della Signoria, Florence, and the four prisoners are in the Accademia, Florence.

Urbano of Pistoia, his pupil, possessed intelligence, he would never take pains, while Antonio Mini though willing had not the aptitude, for hard wax does not take a good impression. Ascanio dalla Ripa Transone worked hard, but never realized anything in works or designs, spending several years over a panel for which Michelagnolo had given him a cartoon.* The high expectations formed about him ultimately vanished in smoke. I remember that Michelagnolo, taking compassion on his slowness, assisted him, but it availed little, and he often told me that if he had had a good pupil he would, old as he was, have done anatomy, and written a treatise upon it to help artists, but he feared that he could not express his ideas as he wished through want of practice in speaking, although in his letters he has clearly expressed his ideas in a few words. He was very fond of reading the Italian poets, especially Dante, whom he much admired, and whose ideas he adopted. Petrarch was also a favourite author of his, and he delighted in composing serious madrigals and sonnets, upon which commentaries have since been

* Ascanio Condivi, author of the rival *Life* of Michelangelo. The cartoon is the *Epifania*, British Museum, London; Condivi's unfinished painting is in the Casa Bunoarotti, Florence

made. M. Benedetto Varchi delivered a notable lecture in the Florentine Academy on the sonnet beginning—

> *Non ha l'ottimo artista alcun concetto,*
> *Ch'un marmo solo in se non circonscriva.* *

He wrote many to the illustrious Marchioness of Pescara,† and received replies from her in both verse and prose. He admired her genius as she loved his, and she often went to Rome from Viterbo to see him. Michelagnolo designed for her a marvellous Pietà with two little angels,§ and Christ on the Cross expiring,‡ a divine thing, as well as Christ and the Woman of Samaria at the Well.** He loved the Bible, like a good Christian, and cherished a great veneration for the writings of Girolamo Savonarola, having heard him preach. He delighted in reproducing human beauty in art, separating the beautiful from the beautiful, without which imitation it is not possible to reach perfection; but he did not indulge

* The best of artists hath no thought to show/Which the rough stone in its superfluous shell/Doth not include (tr. Symonds) †Vittoria Colonna. § Isabella Stewart Gardner Museum, Boston ‡ British Museum, London ** Lost

in lascivious thoughts, which he avoided, as he
showed by his virtuous life, devoting himself to work
when a youth, and resting content with a little bread
and wine, while he showed himself very temperate
as an old man, taking his nourishment in the evening
after the day's work, until he had finished his Last
Judgment. Although rich he lived like a poor man,
and friends never or rarely ate at his table. He did
not like presents, as he always felt obliged to make a
return. His sobriety made him watchful and sleep-
less, and he often rose at night, unable to sleep, to
use his chisel, making a helmet of paper, and keep-
ing a lighted candle above the middle of his head,
which lighted the work without embarrassing his
hands. Vasari, who often saw the helmet, noticed
that he did not use wax lights, but candles made of
goat fat, which are excellent, and sent him four
packets weighing forty pounds. His servant brought
them to him at two in the morning, and when
Michelagnolo refused them he said, 'Sir, they have
broken my arms, and I don't want to take them back
to the house; before your door there is a heap of
mud, they will stand easily in that, so I will light
them all.' The master said, 'Put them down, I do not
want you to play pranks at my door.' They say that
in his youth he often slept in his clothes, as if being

tired by work he did not wish to undress and have the trouble of dressing again.

Some have called him miserly, but they are wrong, for in art and in life he has shown himself the contrary. Thus he gave to M. Tommaso de' Cavalieri, M. Bindo, and Fra Bastiano designs of considerable value, and to Antonio Mini, his pupil, all his designs, cartoons, the Leda, and models in clay and wax, which went to France. To Gherardo Perini, a Florentine noble, he gave some divine heads on three plates, which came into the hands of the most illustrious Don Francesco, prince of Florence, who treasures them as jewels, as they are. To Bartolommeo Bettini he gave a cartoon of Cupid kissing Venus, a divine thing, now in the possession of his heirs in Florence.* For the Marquis del Vasto he did a cartoon of a Noli me tangere;† both works excellently painted by Pontormo. He gave the two captives to Sig. Ruberto Strozzi, and to Antonio his servant and to Francesco Bandini he presented the Pietà which he had broken. I do not think a man who gave such things, worth thousands of scudi, can be taxed with avarice. What is more, I know that he did several designs and went to see many paintings

* Lost † Lost

and buildings for which he never gained anything. With regard to the money he earned, he won it by his labour, and not by offices or exchanges, and before calling him miserly we must remember that he succoured many poor, secretly provided the dowry of a good number of girls, and enriched those who helped and served him, as, for example, Urbino, whom he made very wealthy and taught. After he had served for some time, Michelagnolo asked him, 'What will you do if I die?' 'Serve another,' he replied. 'Poor fellow,' said his master, 'I will protect you from want,' and he gave him 2,000 scudi at one time, the act of an emperor or a pope. He would sometimes give his nephew 3,000 or 4,000 scudi, and finally left him 10,000 scudi, besides the property at Rome.

Michelagnolo possessed a tenacious memory, and retained anything he had once seen, so that he could use it; and he never did two things alike, because he remembered everything he had done. In his youth he was one day with some painters, and they were amusing themselves by making figures without design, like the things scratched on walls. Here his memory proved an advantage, for he recalled one of these and drew it as if it had been before his eyes, surpassing all the others, a difficult

thing in a man so full of designs, accustomed to trace nothing but the most correct figures. He was justly haughty to those who injured him, but never sought revenge, he rather endured patiently, being most modest, prudent, and wise in speech, answering with gravity and sometimes with pleasant and witty words. Many of his sayings were noted, and I will give some, though it would take too long to relate all.

One day in discussing death, a friend said that he must regret that his continuous labours in art allowed him no rest 'That is nothing,' he answered, 'for if life pleases us we ought not to be grieved at death, which comes from the same Master.' A citizen once found him contemplating Donatello's St Mark on Orsanmichele in Florence, and asked him what he thought of it. He replied he had never seen a man who looked more virtuous, and if St Mark was such he could believe all that he had written. A design was shown to him by a child who was then learning, and when some excused the boy, saying he had not long been studying art, Michelagnolo retorted, 'That is clear.' He said much the same to a man who had painted a Pietà, and had not acquitted himself well, remarking that it was a pitiful sight (*pietà*) to see. Learning that Sebastiano of Venice

was going to paint a friar in the chapel of S. Pietro in Montorio, he said this would spoil the work. When asked why he replied, 'They have spoiled the great world, so it will be no great matter for them to ruin a little chapel.' A painter had devoted much time and labour upon a work, and made a good deal out of it on its being uncovered. When asked his opinion of the artist Michelagnolo said, 'While he is eager to be rich he will always remain poor.' A friend who said mass and was a monk, came to Rome in his pilgrim's attire and saluted Michelagnolo, who pretended not to recognize him until the man was compelled to say his name. Michelagnolo expressed surprise at seeing him so dressed, and then added, as if with joy, 'How good it would be for your soul if you were within such as you seem without.' The same man recommended a friend to Michelagnolo, who gave him a statue to do. When the friar asked that something more might be given him Michelagnolo readily agreed; but the friar had acted from envy, thinking his request would not be granted, and when he saw what had been done he was displeased. This was reported to Michelagnolo, who said that nothing annoyed him more than these gutter men, using an architectural metaphor meaning that it is impossible to deal with those who have two mouths. A

friend asked him what he thought of one who had copied some of the most celebrated antique marble figures, boasting he had imitated them, and had far surpassed the ancients. 'One who follows others never surpasses them, and a man who cannot do good original work is unable to use those of others to advantage.' A painter had done a work containing some cattle which were better than all the rest. Some one asked why he had made them more life-like than the other things. Michelagnolo replied, 'Every painter draws himself well.' When passing S. Giovanni in Florence his opinion of the gates was asked: 'They are so beautiful that they would adorn Paradise,' he replied. He served a prince who changed his plans daily. Michelagnolo said to a friend, 'This prince has a mind like a weathercock, turned by every wind.' He went to see a sculpture which was to be put out of doors, and the sculptor was taking pains to arrange the lights of the windows to show it to advantage. Michelagnolo said, 'Do not trouble, the light of the piazza is what you have to fear,' meaning that the popular opinion decides upon the worth of public works. There was a great prince who wanted an architect in Rome, and had made some niches to hold figures three quadri high, with a ring at the top, and in these he

put statues, which did not prove a success. He asked Michelagnolo what he should do, who replied, 'Group eels round the ring.' One of the governors of St Peter's was a signor who professed to understand Vitruvius and to be a judge. Michelagnolo was told, 'You have a man of great mind for your building!' —'That is true,' he replied, 'but of bad judgment.' A painter had made a scene containing nothing but what was borrowed from drawings and other works. It was shown to Michelagnolo, and an intimate friend asked his opinion. He answered, 'He has done well, but at the day of judgment, when all bodies will recover their members, nothing will be left of it,' a warning to artists to use their own wits. At Modena he saw many excellent terracotta works coloured like marble by Antonio Bigarino, who could not work marble. He said, 'If this clay should become marble, woe to the ancient statues.' He was told that he ought to take up the challenge of Nanni di Baccio Bigio, who was continuously competing with him. But he replied, 'He who competes with inferiors gains no glory.' A priest and friend said, 'It is a pity you have not married, as you might have had several children and left left them the fruit of your labours.' He answered, 'I have a wife too many already, namely this art, which harries me incessantly,

and my works are my children, and they will live a while however valueless. Woe to Lorenzo di Bartoluccio Ghiberti if he had not made the doors of S. Giovanni, for his children and nephews have sold and destroyed everything he did, whereas they still stand.' One night Vasari was sent by Julius III to Michelagnolo for a design. He found the master engaged upon the marble Pietà which he broke. Recognizing the knock, Michelagnolo rose and took a lantern. When Vasari had explained his errand, he sent Urbino for the design and began to speak of other things. Vasari's eyes wandered to a leg of Christ which he was trying to alter, and in order that Vasari might not see it he let the lantern fall, and so they were in the dark. He called Urbino to bring a light, and he came out of his place and said, 'I am so old that death frequently drags at my mantle to take me, and one day my person will fall like this lantern.' However, he liked the society of some men, such as Menighella, a clumsy painter of Valdarno but a very pleasant man, who sometimes came to him, and for whom he drew St Roch or St Anthony to paint for the peasants. Michelagnolo, whom it was hard to persuade to work for kings, put aside everything to make simple designs suitable to his friend's style and requirements as Menighella said. Among

other things he did a model of a Crucifix of great beauty. Of this he formed a model, and formed copies which he went about selling. He would make Michelagnolo burst with laughter, especially in relating his adventures. For example, a labourer wanted Menighella to paint a St Francis, but did not like the grey robe, as he desired a brightly-coloured one, so Menighella made him a brocaded cope and he was satisfied. Michelagnolo also liked Topolino the carver, who thought himself a good sculptor, though he was a very poor one. He remained many years in the Carrara mountains sending marble to Michelagnolo, and never loaded a boat without sending three or four little figures of his own, at which Michelagnolo died of laughing. Finally, having sketched a Mercury in marble he gave it to Topolino to finish, and when it was nearly done he wished to see it and give his opinion. 'You are a fool, Topolino,' he said, 'to want to make figures. Don't you see that this Mercury is braccia short from the knees to the feet, and is dwarfed and deformed? 'That is nothing,' he replied, 'if that is all I will put it right, leave it to me.' Michelagnolo laughed at his simplicity and departed. Topolino then took a piece of marble, and cutting under the knees, gave the figure a pair of boots, thus concealing the joint. When

Michelagnolo returned he laughed again, and marvelled that a blunderer should have more resource than a skilled man.

While Michelagnolo was finishing the tomb of Julius II, he caused a stone-cutter to execute a caryatid to be placed on the tomb of S. Pietro in Vincoli, saying, 'Cut away here, plane it here, polish it there,' so that the man had made a figure without knowing it. When he looked at what he had done in amazement, Michelagnolo said, 'What do you think of it?' 'It looks well,' he replied. 'I am much obliged to you.' 'Why?' 'Because through you I have found a talent which I did not think I possessed.'

But to make the story shorter I will only add that Michelagnolo enjoyed excellent health, being thin and wiry, and had only suffered two important maladies as a man, though he had been a delicate child. He supported every fatigue, but in his old age he suffered with his kidneys, and finally with the stone, of which his friend Realdo Colombo cured him by means of injections after many years. He was of medium stature, with broad shoulders, though in proportion with the rest of the body. He wore when old dog's skin next the skin of his legs during winter, and when he wished to remove them, the skin often came with it. Over his stockings he wore shoes of

Cordovan leather, to prevent the swelling of the limbs. His face was round, his forehead square and roomy with seven straight lines, and his temples projected considerably beyond his ears, which were large and projecting. His body was in proportion to his face and somewhat large; his nose was flat, having been broken, as related in the *Life* of Torrigiani; his eyes were rather small, of horn colour, with blueish-yellow spots. His lids had few hairs, his lips were thin, the lower thicker and projecting a little more than the upper. His chin was well-proportioned; his beard and hair were black sprinkled with many white hairs, his beard not being very long or thick, and bifurcated. He was sent into the world by God to help artists to learn from his life, his character, and his works what a true artist should be. I thank God that I have experienced one of the greatest boons an artist can enjoy, in being born in his time, in having him for a master, and having friendly relations with him, as any one of his letters to me testify. Indeed, owing to his friendship I have been able to write many true things about him which others could not have done. The other advantage is, as he often reminded me, 'Giorgio, thank God for giving you a patron like Duke Cosimo, who carries out his ideas and plans without thinking of the

expense, for you know that others whose lives you have written have not experienced this.'

Michelagnolo was buried in S. Apostolo, in the sight of all Rome, with honoured obsequies, attended by all artists, his friends, and the Florentines. The Pope intended to erect a special memorial to him in St Peter's.

Lionardo, his nephew, did not reach Rome until all was over, although he had travelled post. He had consulted Duke Cosimo, who wished the body to be brought to Florence with every imaginable pomp, that he might honour the master as he had not been able to do when alive. It was secretly wrapped up like merchandise, in order to avoid a disturbance in Rome, which might have prevented the removal. Before the body arrived the principal painters, sculptors, and architects of the academy heard of it, at the request of their lieutenant, Don Vincenzio Borghini, who reminded them that by their articles they were bound to honour the death of all their brethren, and having affectionately done so on the decease of Fra Giovann' Agnolo Montorsoli, who died before the founding of the academy, they should do the same to honour Buonarroti, who had been unanimously elected as the first academician and chief of them all. They all answered that they

would do everything in their power. It not being easy for them all to meet every day, they elected a committee of four for the obsequies, Angelo Bronzino and Giorgio Vasari, painters, and Benvenuto Cellini and Bartolommeo Ammannati, sculptors, all distinguished in their arts, to consult with the lieutenant, and decide what was to be done, with full powers from the company. They undertook the charge gladly, because both young and old came forward, offering to do the requisite paintings and statues. They then arranged that the lieutenant by virtue of his office, and the consuls in the name of the company, should inform the duke and ask for his aid and favour, especially that the obsequies might be performed in S. Lorenzo, which contained the principal part of Michelagnolo's work in Florence, and that the duke should allow M. Benedetto Varchi to pronounce the funeral oration, so that the artist's genius might be praised by the eloquence of that great man, who would not have undertaken this charge without a word from the duke, in whose service he was, although, as he loved and admired the memory of Michelagnolo, they felt certain he would not refuse. This done they separated, and the lieutenant wrote to the duke in these words :—

The academy and company of painters and sculptors having decided to honour the memory of Michelagnolo Buonarroti, if your Excellency wills it, as the greatest artist of all time, and especially as a fellow countryman, and in consideration of the great advantages which the arts have derived from the perfection of his works and inventions, think ourselves bound to make the utmost possible return to his genius. They have intimated this desire to your Excellency in a letter asking for assistance. They have asked me, and I feel bound by virtue of my office of lieutenant, to which your Excellency appointed me for this year, because the matter seems most fitting, and much more because I know how much your Excellency favours genius, protecting them in this age, and even surpassing your ancestors, and as Lorenzo the Magnificent directed the erection of a statue to Giotto in the principal church, and a handsome marble tomb to Fra Filippo at his own cost, and many other things on various occasions, I have ventured to recommend to your Excellency the petition of the academy to honour the virtue of Michelagnolo, a pupil of the school of Lorenzo the Magnificent, which will give the greatest pleasure to them and to all, and be no small incitement to artists, and show all

Italy the goodness and greatness of your Excellency. May God long preserve your life to be a blessing to your people, and a support to genius.

The duke replied:—

Reverend and well beloved,—The readiness shown by the academy to honour Michelagnolo Buonarroti, has afforded us much consolation after the loss of such a man, and not only will we grant what the memorial requests, but we will have his body brought to Florence, in accordance with his wish as we are advised. We have written thus to the academy exhorting them to employ every means to celebrate the genius of that great man. God be with you.

The letter of the academy referred to was in these terms:—

Most illustrious duke,— The men of the company of design, created by your favour, knowing that by means of your Excellency's ambassador the body of Michelagnolo Buonarroti is to be brought to Florence, have assembled to discuss the celebration of his obsequies in the best manner

possible. Knowing your Excellency's love for Michelagnolo, they beseech you first to grant that they may celebrate the obsequies in the church of S. Lorenzo, built by your ancestors, and containing such beautiful works by him both in sculpture and architecture, near which it is proposed to build a school for the continual study of architecture, sculpture, and painting for the said academy. Secondly, they beg you to cause M. Benedetto Varchi not only to compose the funeral oration, but to deliver himself as he has freely promised if your Excellency will consent. Thirdly, they beseech you to employ the same goodness and liberality in assisting in the requirements of the obsequies, thus helping the academy whose resources are very small. All these questions have been discussed before M. Vincenzio Borghini, prior of the Innocenti, your Excellency's lieutenant in the academy, etc.

The duke made the following reply:—

Well beloved,—We are content to satisfy fully all your petitions, such is the affection, we bear to the rare genius of Michelagnolo Buonarroti and to all of your profession. However, do not abandon what you propose to do for the

obsequies, and we will not fail to remember your needs. M. Benedetto Varchi has been written to for the oration, and the master of the hospital is instructed to do what pertains to him. Farewell. From Pisa.

The letter to Varchi ran:—

M. Benedetto, our well beloved: our affection for the rare genius of Michelagnolo Buonarroti makes us desire to honour his memory in every possible way, and we should be delighted if you would kindly recite the funeral oration, especially if you pronounce it yourself according to the arrangements made by the deputies of the Academy. Farewell.

M. Bernardino Grazzini also wrote to the deputies saying that the duke could not possibly have been more anxious in the matter, and he would give every assistance. While these things were going on in Florence, Lionardo Buonarroti, who on hearing of his uncle's illness had gone post to Rome, though he arrived too late, learned from Daniello of Volterra, a very intimate friend of Michelagnolo, and others who had been about the good old man, that he had

begged that his body might be taken to his noble country, Florence, which he had always loved. Lionardo therefore hurriedly but with caution removed the body from Rome and forwarded it to Florence like merchandise.

With regard to this last wish of Michelagnolo, the truth is that his long absence from Florence was due to nothing but the air, which being sharp and subtle proved injurious to his health, while in the more temperate climate of Rome he remained healthy until his ninetieth year, in the full enjoyment of all his faculties, and so strong that he worked up to the very last day.

The body reached Florence suddenly and almost unexpectedly on Saturday, March 11, and was placed below the high altar in the company of the Assunta, and below the steps behind the high altar of S. Piero Maggiore. That day nothing was done. The following day being the second Sunday in Lent, all the painters, sculptors, and architects met about S. Piero bringing nothing but a velvet pall with gold fringe to cover the coffin, on which lay a crucifix. At midnight they all stood about the body, the oldest and best artists supplying a quantity of torches, the younger men crowding to carry the bier, esteeming themselves happy if they could raise it on

their shoulders, to be able to boast in after days of having borne the body of the greatest man of their art. Many persons who had seen them gathered about S. Piero, especially when it was bruited that the body of Michelagnolo had come and was to be carried to S. Croce, and although every precaution to secure secrecy had been taken, the report spread, and such a crowd assembled that some tumult and confusion arose, though quiet rather than pomp was desired, the rest being reserved for a more convenient time. But the contrary happened, because the news spread and the crowd filled the church in a twinkling, so that the body could only be taken to its resting place in the sacristy with the utmost difficulty. Although a number of monks, a quantity of candles, and many people dressed in black make a magnificent show at funerals, it was certainly a great thing to see so many excellent men suddenly gathered into one band, some of whom are distinguished now, and others will some day be even more so, performing the last rites about the body. All the artists in Florence were there, and they have always been very numerous. Indeed the arts have always so flourished there, that without offence to other cities I may call Florence the nest and home of the arts, as Athens was of the sciences. Besides the artists a great

number of citizens followed, and those standing at the sides blocked the way. What is more, all spoke the praises of Michelagnolo, and said that a great man is honoured for his worth even after no more can be expected from him. For these reasons the demonstration was more significant than the greatest ceremony with gold and banners. Arrived at S. Croce the friars performed the usual rites.

The man who was to perform the office, thinking to please many, and, as he afterwards confessed, desiring to see dead one whom he had not seen alive, except at an age when he could not remember, decided to open the coffin. Those present expected to see signs of decay, as he had been dead twenty-five days, and twenty-two in the coffin, but we saw him untouched, without any bad smell, so that he seemed to be quietly sleeping. His features were almost exactly as in life, except a slight colour of death, and not a member was impaired, the head and cheeks being as if he had only been dead a few hours. The press of the crowd being over, it was decided to put him by the Cavalcanti altar near the door leading into the cloister of the chapter-house. Meanwhile the news spread, and such crowds of youths came to see him that it was very hard to shut the coffin. If it had been day instead of night, it

would have been necessary to keep it open many hours to satisfy the crowd. The following morning while the painters and sculptors were beginning to arrange the ceremony, the numerous wits, who always abound in Florence, pinned Latin and Italian verses to the coffin, and this was continued so that the number printed formed a small part of those written.

To come to the obsequies. They were not solemnized on St John's day, but postponed to July 14. Benvenuto Cellini being somewhat indisposed, the other three deputies after making Zanobi Lastricati, the sculptor, provveditore, decided to produce something ingenious and worthy of their art rather than a pompous and costly ceremonial. Indeed they said that artists in honouring a man like Michelagnolo ought not to seek royal pomp or superfluous vanity, but ingenious and charming inventions, to display their knowledge, art thus honouring art. Thus although we knew the duke would supply any amount of money, as we had already asked and received much, we decided to have something artistic and beautiful rather than rich and costly. Nevertheless the magnificence was equal to anything ever done by the academicians, and the honour was as remarkable for magnificence as for ingenious

inventions. It was finally arranged to have the catafalque in the middle nave of S. Lorenzo between the side doors, one leading into the cloister, the other into the street. It was rectangular, twenty-eight braccia high with a Fame at the top, sixteen braccia long and nine broad. The catafalque was raised two braccia from the ground by a pedestal, the side towards the principal entrance bearing two beautiful recumbent rivers, the Arno and the Tiber. The Arno had a cornucopia full of flowers and fruits, to signify the fruitfulness of Florence in their professions, which have filled the world, and especially Rome, with extraordinary beauty. The other figure holds in its extended arms flowers and fruits from the cornucopia opposite. This showed that Michelagnolo had spent a great part of his life at Rome, and there produced the marvels that amaze the world. The Arno had the lion as a sign, and the Tiber the wolf with the little Romulus and Remus. Both were colossal figures, resembling marble, of extraordinary grandeur and beauty. The Tiber was by Benedetto da Castello, a pupil of Baccio Bandinelli, the other by Battista di Benedetto, a pupil of Ammannato, both youths of the highest promise. From the pedestal rose a front of $5\frac{1}{2}$ braccia with cornices beneath, above, and at the sides, leaving a space in

the middle, four braccia square. On the front of the rivers was painted Lorenzo de' Medici receiving the little Michelagnolo into his garden, having heard of the first-fruits of his great genius. This was painted by Mirabello and Girolamo del Crocifissaio, great friends, who resolved to do the work together. They displayed great vigour in the attitude of Lorenzo, a portrait from life, graciously receiving the respectful child, and after examining him, consigning him to some masters to be taught. The second scene following this, towards the side door opening on the street, represent Pope Clement showing favour to Michelagnolo, and employing him on the library and new sacristy of S. Lorenzo, contrary to the general opinion, which supposed that the Pope was angry with the artist for the part he had played in the siege of Florence. This was by the hand of Federigo Fiammingo, called del Padoano, painted with great dexterity and smoothness, showing Michelagnolo showing the Pope the plan of the sacristy. Behind him little angels and other figures bore models of the library, the sacristy, and the statues there, all executed with great diligence. The third square, facing the high altar, contained a great Latin epitaph composed by the learned M. Pier Vettori, which ran :—

Collegium pictorum, statuariorum, architecto-
rum auspicio opique sibi prompta Cosmi ducis
auctoris suorum commodorum, suspiciens singu-
larem virtutem Michaelis Angeli Buonarrotae,
intelligensque quanto sibi auxilio semper fuerit
praeclara ipsius opera, studuit se gratum ergo
illum ostendere, summum omnium, qui unquam
fuerint, P.S.A. ideoque monumentum hoc suis
manibus extructum magno animi ardore ipsius
memoriæ dedicavit.

This epitaph was borne by the angels, each
weeping and extinguishing a torch, lamenting at the
extinction of such rare genius. The last scene oppo-
site the door leading to the cloister represented
Michelagnolo fortifying S. Miniato for the siege of
Florence, which was considered impregnable and

* The Academy of Painters, Sculptors, and Architects, under the
auspices and with the aid of Duke Cosimo de' Medici, their head
and guarantor of all these comforts, admiring the extraordinary
genius of Michelangelo Buonarroti, and acknowledging the ben-
efits received from his divine works, has attempted to demonstrate
its gratitude to the greatest of all artists, sculptors and architects,
and to this end, with their own hands and with great ardour of
spirit, has erected and dedicated this monument.

marvellous. This was by Lorenzo Sciorini, a pupil of
Bronzino, and a youth of great promise. The lower
part or base had a projecting pedestal on each side
containing a statue of more than life size, with an-
other beneath conquered and subdued, of the same
size, but in curious attitudes. The first on the high
altar side was a slender youth of great spirit and
beauty, representing Genius, with two wings on his
temples, such as Mercury sometimes wears, and
below him was Ignorance, the mortal enemy of
Genius, a fine figure with ass's ears, made with
incredible diligence. Both these statues were by
Vincenzio Danti of Perugia. I shall speak of him and
of his rare works more at length elsewhere. On the
second pedestal, facing towards the new sacristy, was
a female figure representing Christian Love, being an
aggregate of all the theological virtues, which the
Pagans called moral. Thus when Christians were cel-
ebrating so worthy a Christian, it was right to find a
place for this Virtue, for without it all other qualities
of the mind and body are of little account. This fig-
ure stood over a prostrate Vice or Impiety by Valerio
Cioli, an ingenious youth worthy of praise as a dili-
gent and judicious sculptor. Towards the old sacristy
was another figure representing Minerva, or Art. For
we may say that after good morals, which take the

first place, follow the arts which provide men with honour, wealth, and glory, while their excellent works secure fame for great men after death, when having passed beyond envy they are by common consent recognized as excellent. For this reason she stood over Envy, a shrivelled hag with viperous eyes and breathing poison, being girded with snakes and holding a viper in her hand. These two statues were by a mere child, Lazzaro Calamec of Carrara, who has displayed a fine vivacious mind in some paintings and sculptures. The two statues on the fourth pedestal opposite the altar were by his uncle, Andrea Calamec, a pupil of Ammannato. The first represented Study, as those who work slowly and little achieve little, while Michelagnolo never rested from work from his earliest childhood to the age of ninety. This Study was a strong and bold youth, with two wings at his wrists, to indicate speed in work. He stood over Slothfulness or Idleness, a lean woman, sleepy and heavy in every act. These four figures formed a charming group and looked like marble, the clay being painted white. On the level where they stood rested another pedestal, about four braccia high, but narrower than the one beneath by the mouldings. Each face had a painting six braccia long and three high, and above it was another surface like

the lower one, only smaller. Each side had a projection for a life-size figure. These were four women, easily recognizable from their instruments as Painting, Architecture, Sculpture, and Poetry. Above the scene of Lorenzo receiving Michelagnolo was a beautiful painting of Michelagnolo presenting his stupendous model of the cupola of St Peter's to Pius IV, a much-admired work painted by Piero Francia of Florence. The statue of Architecture on the left of it was by Giovanni di Benedetto of Castello, who had been so successful with the Tiber already described. The second scene facing the side door represented Michelagnolo painting his Last Judgment, the model for all foreshortening and other difficulties of art. This was done with much grace and diligence by the apprentices of Michele di Ridolfo. The statue of Painting on the left, facing the new sacristy, was by Battista del Cavaliere, a youth no less excellent as a sculptor than for his admirable character. The third picture facing the high altar represented Michelagnolo apparently consulting a female Sculpture, who holds a tablet with the words of Boethius, *Simili sub imagine formans.** The painting

* 'In perfect beauty Thou movest in Thy mind a world of beauty, *making all in a like image...* (*Consolation of Philosophy*, III)

was executed with excellent invention and style by Andrea del Minga, and the statue of Sculpture on the left, of not inferior merit, was by Antonio di Gino Lorenzi, sculptor. The fourth scene represented Michelagnolo writing his compositions surrounded by the nine Muses as described by the poets, and Apollo in front with his lyre and laurel crown, and holding another crown which he offers to place on Michelagnolo's head. This beautiful and finely-composed work, with its vigorous attitudes, was by Giovanmaria Butteri, the statue of Poetry on the left being by Domenico Poggini, equally skilled in sculpture, making medals, working bronze, and writing poetry.

Such was the decoration of the catafalque, which resembled the mausoleum of Augustus at Rome, though, being rectangular, it was perhaps more like the Septizonium of Severus, the true one printed next the Antonianus in the *Nuove Rome,* not the one near the Capitol, commonly but erroneously so called. On the topmost pedestal was a base a braccia high and somewhat less in breadth and length upon which the figures were seated, with the legend about them: *Sic ars extollitur arte.** Upon the

* Thus art extolls art.

base rested a pyramid nine braccia high, the sides of which facing the principal door and the high altar bore medallions with the portrait of Michelagnolo in relief, excellently done by Santi Buglioni. At the top of the pyramid was a ball in proportion, as if it contained the ashes of the deceased, and upon it rested a life-size Fame, painted like marble, in the act of flying and spreading the praises of the great artist with a trumpet having three mouths. Zanobi Lastricati made this figure, for in spite of his labours as director he wished to show his skill and ability. The height from the ground to the top of the Fame was twenty-eight braccia. The whole church was draped with black hangings, not as customary, fixed to the central columns only, but at the surrounding chapels, and every space between the pilasters was decorated with some painting, affording both wonder and delight. In the space of the first chapel next the high altar, and by the old sacristy, was a painting six braccia high by eight long, representing Michelagnolo in the Elysian fields, and on his right figures larger than life of the famous painters and sculptors, each distinguished by some sign: Praxiteles by the satyr in the villa of Julius III, Apelles by the portrait of Alexander the Great, Zeuxis by the picture of the grapes which deceived the birds, and Parrhasius with the curtain which

deceived Zeuxis. They were accompanied by later artists from the time of Cimabue. Giotto bore a tablet with the portrait of young Dante like that painted by Giotto in S. Croce; Masaccio was a portrait; so also was Donatello, who had his Zuccone of the Campanile beside him; Brunelleschi had his cupola of S. Maria del Fiore. Other portraits were those of Fra Filippo, Taddeo Gaddi, Paolo Uccello, Fra Giovanni Agnolo, Jacopo Pontormo, Francesco Salviati, and others, all welcoming Michelagnolo as the divine poet Dante represents them as welcoming Virgil, and a line of the poet was written on a letter held by the river Arno, which is lying in a beautiful attitude at Michelagnolo's feet:—

Tutti l'ammiran tutti onor gli fanno. *

This painting was by Alessandro Allori, pupil of Bronzino, and not unworthy of his great master, for it was greatly praised by all who saw the work. The space of the chapel of the Sacrament at the crossing contained a painting, five braccia by four, of the school of the arts, children, up to men of twenty-four, surrounding Michelagnolo and offering him

* 'All render homage, all do him honour'. (*Inferno*, IV, 133)

the first fruits of their labours in paintings and sculptures, which he graciously receives, teaching them art while they listen attentively in attitudes full of grace and beauty. The composition of this scene could not be improved upon, and Batista, a pupil of Pontormo, who painted it, received great praise. The verses at the bottom ran:—

Tu pater, tu rerum inventor, tu patria nobis
*Suppeditas praecepta tuis ex, include, chartis.**

Proceeding towards the principal door and before reaching the organ, there was a chapel space six braccia high by four broad, containing a repres-netation of the extraordinary favour shown by Julius III to Michelagnolo in entertaining him at his villa to consult him on some buildings. The master is seated beside the Pope, and they converse together, while the cardinals, bishops, and other courtiers remain standing. This is harmoniously composed and in excellent relief, the figures being vigorous, so that an old and experienced master might not have

* 'You are our father, you are creator of things, you are our home. Your designs, great man, supply models in abundance.' (Lucretius, *On the Nature of Things*, III, 9-10)

done better. The artist, Jacopo Zucchi, therefore, a young pupil of Giorgio Vasari, showed great promise in this work. Not for off and somewhat below the organ Giovanni Strata, a skilful Flemish painter, had represented in a space six braccia long by four high, Michelagnolo's visit to Venice, during the siege of Florence. To his lodgings on the Giudecca there, the doge Andrea Gritti and the Signoria sent nobles and others to make offers to him, the painter showing much judgment and knowledge in the whole composition and in every detail, such as the attitudes, the animated faces, the movements of each figure, the invention, design, and excellent grace.

To return to the high altar. In the first picture next the new sacristy, in the space of the first chapel, painted by Santi Titi, a youth of good judgment and considerable experience in painting in Florence and Rome, represented another signal favour accorded to Michelagnolo in Rome three years before he died by Sig. Francesco Medici, Prince of Florence, who on Buonarroti's entrance immediately arose; and courteously offered him his seat, standing himself reverently to hear him, as sons hear a good father. At the feet of the prince was a boy, executed with great diligence, holding a ducal cap, and about them stood soldiers dressed in the ancient style, excellently

done. But the best figures were those of the prince and Michelagnolo, the elder man speaking and the younger listening attentively. In the picture opposite the tabernacle of the Sacrament, nine braccia high by twelve long, Bernardo Timante Buontalenti, a favourite painter of the prince, had beautifully represented the rivers of the three principal parts of the world grieving with the Arno at the common loss, namely the Nile, Ganges, and Po. The sign of the Nile was a crocodile and a fertile country with a garland of wheat to show the fertility of the country; the Ganges had a griffin and a garland of gems, while the Po had a swan and a crown of black amber. These rivers are led to Tuscany by Fame, a flying figure, and surround the Arno, who is crowned with cypress and holds up an empty urn and a cypress-branch, while beneath her is a lion. To show that Michelagnolo's soul had gone to bliss, the painter had represented a splendour in the air, and a little angel with the lyric line:—

Vivens orbe peto laudibus aethera. *

On pedestals at the sides stood two figures

* 'Living in the wide world, I fly with my praises to Heaven'

holding back a curtain, disclosing the rivers, Michelagnolo and Fame. Each figure stood over another. The one on the right, representing Vulcan, held a torch, and below him was Hatred, struggling to rise. A vulture bore the legend:—

Surgere quid properas Odium crudele? Jaceto. *

because superhuman things ought neither to be hated nor envied. The other figure was Aglaia, one of the Graces and the wife of Vulcan, representing Proportion. She held a lily, a flower dedicated to the Graces and suitable for funerals. She stood over Disproportion with an ape or monkey and this line above:—

Vivus et extinctus docuit sic sternere turpe.†

Below the rivers were two more lines:—

Venimus, Arne, tuo confixa ex vulnera moesta
Flumina, ut ereptum mundo ploremus honorem.§

* 'Why do you hasten to rise, cruel Hatred? Lie prostrate.' † 'Alive and dead he taught to subdue what is ugly.' § 'We, sorrowful rivers, united with you, Arno, in your grief are coming to lament that honour has left the world.'

The picture was considered very fine for its invention, the beauty of the verses, the general composition, and the charm of the figures. As the artist did not receive a commission, but produced it of his own accord to honour Michelagnolo, he deserves the greater praise. Another picture six braccia long by four high, near the side door, by Tommaso da San Friano, a young artist of ability, represented Michelagnolo sent to Julius II by Soderino as ambassador of Florence. Not far from this, a little below the side door, was another picture: Stefano Pieri, pupil of Bronzino, a diligent and studious youth, painted Michelagnolo seated beside Duke Cosimo, and conversing with him, a thing that had frequently happened in Rome. Above the black draperies surrounding the church were images of death, devices and other such things, different from what are usually made, and exhibiting much beauty and fancy. Some of the figures of Death seemed to be sorrowing at having to remove such a man, and bore a scroll with the words *Coegit dura necessitas.* * Nearby was a world from which sprang a three-headed lily, the stalk of which was broken, a clever idea due to Alessandro Allori. Other figures of Death were

* 'Hard necessity requires it.'

made in different ways, but most praise was given to Eternity, holding a palm, and her feet on the neck of one in a disdainful pose, as if to say that Michelagnolo would live in spite of all. The motto was *Vincit inclita virtus*,* and the design Vasari's. Each of the figures of the Death bore Michelagnolo's device of three crowns or circles interlaced, used either to indicate the three professions of sculpture, painting and architecture, which cannot be separated, or with some subtle meaning, as he was a man of great intelligence. The academicians considering him perfect in all three, changed the circles into crowns with the motto *Tergeminis tollit honoribus*,† to show that he deserved the crown in each profession. In the pulpit where Varchi pronounced the funeral oration, afterwards printed, there was no decoration, the bas-reliefs being by the great Donatello, and much finer than any decoration that could have been attempted. The opposite one not having then been raised on the columns, a picture four braccia by two was placed on it, representing Fame or Honour, a youth with a trumpet in his right hand and treading on Time and Death to show that Fame and

* 'Renowned merit is victorious.' † 'He is raised to triple honours.' (Horace, *Odes* I, i, 8.)

Honour keep alive those who have produced great works, in spite of time and death. This was by Vincenzio Danti, sculptor of Perugia.*

The church being thus adorned, filled with lights and packed with a great crowd, for men left everything to see this sight, the lieutenant of the academy entered accompanied by the halberdiers of the duke's guard, the consuls and the academicians, in fact all the painters, sculptors and architects in Florence. These were seated between the catafalque and the high altar, and a great number of nobles placed in order of precedence. Then followed the solemn mass of the dead, at the conclusion of which Varchi mounted the pulpit, though he had not performed such an office since the funeral of the Duchess of Ferrara, Duke Cosimo's daughter, and there pronounced the eulogy of the divine Michelagnolo, with his unique eloquence. It was indeed a great good fortune for Michelagnolo that he did not die before the foundation of our academy, as his death would not then have been so sumptuously celebrated. It was also his good chance to die before

* Apart from a few drawings, nothing survives of any of the funeral art described by Vasari. However, a series of 17th century paintings in the Casa Buonarroti are clearly based on these descriptions.

Varchi and obtain the eulogy of that great man, which was printed, as well as another fine oration in praise of Michelagnolo and his works by the noble and learned M. Leonardo Salviati, then about twenty-two, and of rare ability in composing in Latin and Tuscan, who will be better known in the future. But what praise can suffice for Don Vincenzio Borghini, the chief director and counsellor of these obsequies? All the artists produced their best work, but it would have been useless without an experienced head to direct everything. As the whole city could not see the apparatus in a single day, as the duke desired, it was left standing for several weeks to the delight of the people and the strangers who came from neighbouring places. I will not add here the numerous epitaphs and Latin and Tuscan verses written in Michelagnolo's praise, as they would form a work by themselves, and they have been published by other writers. But I will add that the duke directed that Michelagnolo should have an honoured tomb in S. Croce, where he had desired to lie beside his ancestors. The duke gave Lionardo Buonarroti the marble, which Batista Lorenzi was to carve after Vasari's design. It contained the head of Michelagnolo and statues of Painting, Sculpture and Architecture, by Batista Giovanni dell'Opera and Valerio Cioli,

Florentine sculptors respectively, who soon finished them and put them in their places. The expense, beyond the marble, was borne by Lionardo, but in order that nothing should be lacking to honour such a great man, the duke has placed his bust and an inscription in the Duomo, which contains similar memorials of the other great Florentines.

List of Illustrations

Illustrations on pp. 1, 6, 14, 20, 41-42, 47, 67, 107, 141-142, 151 and 253 courtesy British Museum; on p. 2 courtesy Pinacoteca di Brera; on p. 4, 18, 23, 53, 62, 71, 72, 92, 108, 138 and 146-47 courtesy Wikimedia Commons; on pp. 13, 121-22 and 158 courtesy Ashmolean Museum; on pp. 27-28 and 31-32 courtesy Teylers Museum; on pp. 36, 60, 88, 94-95, 98, 101, 102 and 104-05 © Jörg Bittner Unna; on p. 57 © Stanislav Traykov; on p. 65 © Livioandronico2013; on pp. 75, 119 and 128-129 courtesy J. Paul Getty Museum; on p. 84 courtesy The Metropolitan Museum of Art; on pp. 90-91, 97, 135 and 188 © Bridgeman Art Library; on p. 181 © Sailko

© 2006, 2013, 2018 Pallas Athene

Published in the United States of America in 2018 by the J. Paul Getty Museum, Los Angeles
Getty Publications
1200 Getty Center Drive, Suite 500
Los Angeles, California 90049-1682
www.getty.edu/publications

Distributed in the United States and Canada by the University of Chicago Press

Printed in China

ISBN 978-1-60606-565-5
Library of Congress Control Number: 2017947348

Published in the United Kingdom by Pallas Athene
Studio 11A, Archway Studios, 25–27 Bickerton Road, London N19 5JT
Series editor: Alexander Fyjis-Walker Editorial assistant: Anaïs Métais

This edition of Vasari's *Life* of Michelangelo is based on the text of the second edition of 1568, translated by A. B. Hinds. A few names of artists have been given in their modern form.

Front cover: Marcello Venusti (Italian, ca. 1512–1579), *Portrait of Michelangelo*, after 1535 (detail). Casa Buonarroti, Florence, Italy. Scala / Art Resource, NY